© 2023 Mandragora. All rights reserved.
First edition 2022

Mandragora s.r.l.
via Capo di Mondo 61, 50136 Firenze
www.mandragora.it

Editors
Maria Cecilia Del Freo, Marco Salucci

Art director
Paola Vannucchi

Printed in Italy by
Grafiche Martinelli, Bagno a Ripoli (Florence)

Bound by
Legatoria Giagnoni, Calenzano (Florence)

Cover illustration
Antonio Franchi, *Portrait of Maria Luisa de' Medici Electress Palatine*, detail. Florence, Galleria delle Statue e delle Pitture degli Uffizi.

By permission of Ministero della Cultura.
Any further reproduction by any means is prohibited.

isbn 978-88-7461-460-8

Marialuisa Bianchi

HISTORY OF
FLORENCE

*The precious legacy of the last Medici princess
who shaped the city's destiny*

Mandragora

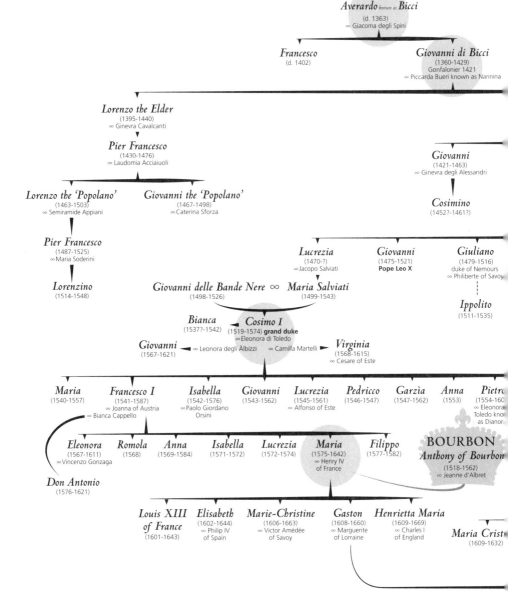

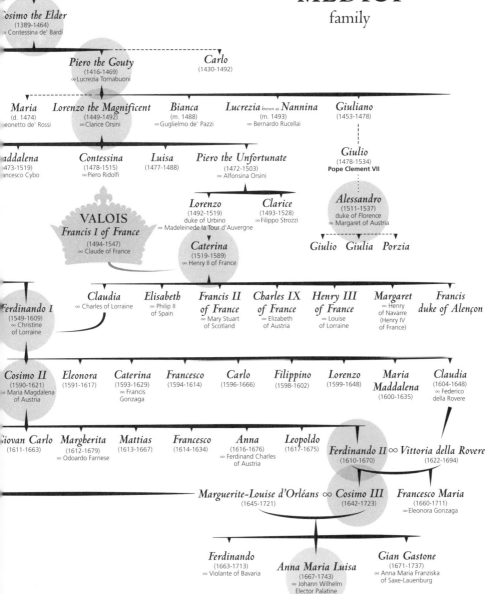

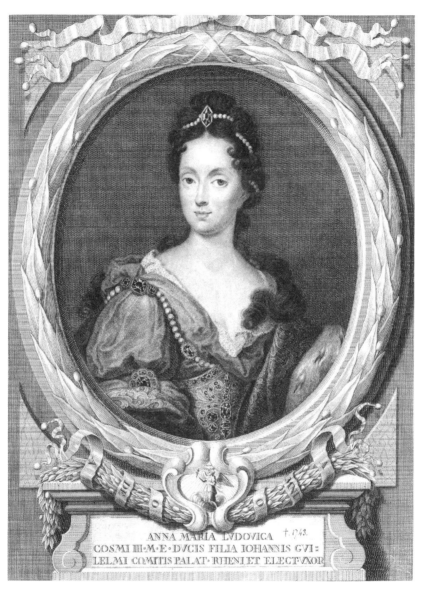

Anna Maria Luisa de' Medici, c. 1695

I. The Promise

"On this day, the Serene Electress hereby cedes, gives and transfers to H.R.H., for Him, and for the Grand Dukes who succeed him, all the Assets, Effects and Rarities resulting from the succession of the Serene Grand Duke her brother, such as Galleries, Paintings, Statues, Libraries, Jewels and other precious things, and also the Holy Relics and Reliquaries, and the Ornaments of the Royal Palace Chapel, which H.R.H. undertakes to preserve, on the express condition that nothing which is for the ornament of the State, for the use of the public, and to attract the curiosity of foreigners will be taken away from the Capital and State of the Gran Duchy."

31 October 1737
Anna Maria Luisa and Francis Stephen of Lorraine

Articolo 111.

La Serenissima Elettrice cede, dà, e trasferisce al presente a S.A.R. per lui, e suoi Successori Granduchi, tutti i Mo= bili, Effetti, e Rarità della Successione del Ser.mo Granduca suo Fratello, come Gallerie, Quadri, Statue, Biblioteche, Gioje, ed altre cose preziose, siccome le Sante Reliquie e Reliquiari, e gli Ornamenti della Cappella del Palazzo Reale, che S.A.R. s'impegna di conservare a condizione espressa che di quelle è ornamento dello Stato, e d'utilità del Pubblico, e per attirare la curiosità dei Forestieri non ne sarà nulla trasportato, o levato fuori della Capita- le, e dello Stato del Granducato.

Le Guardarobe, Mobili, Argenterie ed Effetti, che sono d'uso, resteranno alla libera disposizione di S.A.R.

Today I have finally affixed my signature to the bottom of this document with which I give everything I own to my city, relieving me of all my obligations. I am proud of what I have done.

The city of Florence is dearer to me than all the wealth I have enjoyed during my lifetime. Dearer to me than my own father, Cosimo II, and my brother Giovanni Battista Gastone de' Medici, known as Gian Gastone, who died last July, may he rest in peace! He left no heirs, just like me, despite the fact that I wanted children so much. It's better that I do not linger on my feelings for my mother Marguerite Louise d'Orléans, who returned to France and left us when I was eight and the little one was just four. Ferdinando perhaps suffered less, as he was already quite grown-up. I do not hold a grudge against the woman whom I never called 'mummy', but that abandonment was certainly painful, especially for my little brother. Calling him little brother reminds me of the great tenderness I felt for the chubby little blonde boy I held in my arms, albeit only for a few minutes because he was heavy. The nurse was afraid that I, a four-year-old girl, might drop him. My mother, Marguerite, laughed and found my predicament entertaining. All she was concerned with was the size of her waist and the heavy lines of the clothes she had to wear to conceal

her still full figure. She was getting ready for the next ball at the villa in Poggio a Caiano where she had moved. Father was keeping an eye on her, because he was worried she might run away to Paris as she had threatened to do. Ultimately, humiliated by the conditions he made her live in, she really did go, with the consent and the support of her cousin Louis XIV, King of France. And she never came back. It happened four years later, with this number playing a recurrent role in our family's history. She used to write to us sometimes in the early days, mostly addressing the letters to my older brother Ferdinando, her favourite, the one who resembled her the most: exuberant, full of life and fun. He was supposed to become grand duke when our father died, but he passed away before him having failed to produce any heirs with the beautiful Violante Beatrice of Bavaria, the poor woman who had to put up with all sorts from him. Ferdinando died due to the excessive love of a singer known as 'Bambagia', whom he had taken with him from Venice and, together with her, the illness with which life betrayed him: the 'French pox'.

After great pressure and endless negotiations, our mother won and went back to live in France subject to the agreement that she would live in a monastery in Montmartre to look after the sick and needy. This is what she told us, in her own tongue: she had always refused to speak Tuscan.

My grandmother Vittoria and my father were always on my side. I had no shortage of care and affection. I was the favourite of my uncle, Cardinal Francesco Maria. I really enjoyed my visits to the villa in Lappeggi, where we always used to spend much of our time laughing together. Both of us were very good humoured. My father insisted that my uncle, who was in his fifties at the time, should divest himself of his ecclesiastical habit and marry the young Eleonora Gonzaga to ensure the continuation of the family line. But no children were born to 'dear old tubby', as I called him affectionately. No little cousins arrived and so the house of Medici remained barren, like a nest where all the eggs had broken. We had no descendants, since Gian Gastone had failed to provide an heir with the 'German woman', my sister-in-law Maria Anna of Saxony, as had I with my elector Johann Wilhelm II, with whom I lived happily for twenty-five years, far from Florence, yet content and fulfilled.

Poor Uncle Francesco! 'I bow humbly to your beautiful belly' I used to say to him when I was young. His marriage destroyed him, mortified by the young woman who didn't want anything to do with this old man and who shunned him constantly. He died shortly afterwards and the following words appeared on the walls of the Palazzo Pitti: 'Up for rent this year / as the Medicis are going'. My dear, fun-loving uncle would have laughed if he'd had the opportunity to read this. Nevertheless, it was hurriedly removed, so that my father did not see it. He certainly would not have laughed. Cosimo III had put all his energy into keeping our glorious dynasty alive and now he had to resign himself to the truth. Perhaps, as the good Christian he claimed to be, he should have seen a sign from God in those barren wombs and in men who had no wish to father children, even if reasons of state demanded it. "Time passes and one is not aware".[1]

And time, which swallows up and devours everything, would now make us disappear too, along with the loving care and attention we had devoted to the arts and beautiful objects that were collected here in Florence by my ancestors. The Austrians who had settled in Tuscany were not much inclined towards culture and good taste, yet presumed to look after the artworks... No, I'm certain they would have dispersed them or even sold off these magnificent and sublime creations that we have in Florence... What would remain of the Tuscan genius? What could I expect when I saw that they had moved some paintings out of the palace rooms because they did not think the frames were sufficiently sumptuous, or simply because the figures were portrayed with their backs to the throne and not inclined towards foolish servitude?

They had even hung portraits of their ancestors over the frescoes in the Palazzo Vecchio. Warriors, hunters, vain and fatuous men, with no culture and no ability to appreciate real beauty. I already knew it deep down, but that was when I began to develop a real understanding of whom we were dealing with. This is why I started studying the history of my city and looking for a solution. The glories of the present can only be drawn from the past, while history is the only thing that helps us to understand who we are and what our task is. And so I recognized the mission that my ancestors had left for me to complete. I, the last of the

Medici family, a childless woman, a pawn in the marriage games of the powerful, had found the right path to follow. I had realized that I had to save the pieces from oblivion and keep them together, reconstructing the tapestry of time and allowing the bright individual threads to reweave the complex picture of my city with precision.

I fought for this and the more I learnt the more I found the strength to oppose the Austrians. In the meantime, I observed the decline of Gian Gastone, his eccentricities, his frenzies of lust. I could do nothing against him. He hated me because I was the one who had arranged his marriage with the German woman. At the time I believed that his twisted nature could be corrected and that their living together would help secure the succession. Now I know how much he suffered and how pointless this effort was for him. My poor brother! It was only on his death bed that he admitted me and forgave me. He received the viaticum in my presence. 'Sic transit gloria mundi' he said as he looked at the crucifix.

However, going back to where we were before... At home he paid no attention to his hygiene, he was always in bed, dirty, in his night-shirt with his nightcap pulled right down. He surrounded himself with *ruspanti*, men of pleasure paid with *ruspi* (coins). Twice a week, swarms of these disgusting individuals gathered in the courtyard of the Palazzo Pitti to be paid and he loved it – I saw them from my window and I was shocked. They spoke and sang dirty songs, while I recited my prayers and plugged my ears with wax.

In the evening I ordered that they be kept away. I was fearful for him, for his safety. One moonless night they entered, giving themselves up to revelry. The following day it was said that they were mercenaries paid by foreign powers, and yet Gastone had enjoyed it so much... and he had laughed, laughed as he had not done for some time. The room stank. He didn't want anyone to clean it or even for me to enter. It was full of the remains of those encounters and the excrement of the dogs he kept to guard his person. He claimed that the world was badly made and we shouldn't take it to heart: it's wiser to laugh about it.

Uncle Francesco, who had been brought up to become pope, soon grew tired of religion and joined in with my brother Ferdinando's parties. He

grew fat and his nephew, seeing him so lacking in zeal for religion, said to him 'May God bless you and remind some friar that you're a cardinal, so that he can convert you'.

In his own way, Gastone laughed at the world and how it had reduced him. I really felt for him, but I couldn't help him. Who knows? If I hadn't schemed for that marriage, would he have remained a bachelor but happy? Perhaps it was fate that our dynasty had to end this way! In the stench of vomit and in orgies!

No, I absolutely had to do something to restore the pieces of the fresco that had been torn up.

And to think that my father had pictured me as queen of France, like Catherine and Marie, offering me as a bride for the 'Dauphin', son of Louis XIV. Those were other times! But the Sun King didn't want me as his daughter-in-law. They said that the match was opposed by my mother, jealous of my possible role at court, which would certainly have overshadowed her. That's just a rumour though.

'His royal highness' Gian Gastone, seventh and last grand duke of Tuscany, a member of the Medici dynasty, had not always been like that. He used to be a good-natured and well-educated, a lover of peace and the arts. As children we performed together in the rooms of the Palazzo Pitti. He accompanied me on guitar and I sang and played the lute. He was touchy, certainly, and as a young man he didn't love amusements or lively company, unlike his brother Ferdinando. He never reached an understanding with his wife; they certainly weren't soulmates. It was such a shame! And it wasn't for lack of trying. He even went to live in Bohemia with her. He grew more and more reserved and when he visited our beloved parent in Paris, his character became even darker. He expected so much from this meeting, but she was curt and formal. She invited him to lunch and that was the end of it all.

He gave into drink and the wildest vices, seeking to crush the great feeling of melancholy that oppressed him. Marguerite's intense imagination and Cosimo's surliness merged in an unhappy young man, who was both moody and wild at the same time. Too sensitive to bear the world.

Our father, who remained alert right up until the end, had always detested him and never allowed him to help him govern despite the fact he would become prince one day! Only once, for the feast of St John, did he allow him to make decisions in his own right. My brother took advantage of this to give the people more freedom, even authorizing women to walk around the city, something that was strictly forbidden at the time. Cosimo went mad and Gastone didn't stop joking, seated on the throne: 'It feels like playing a king in a comedy'. That's just how it happened. I heard the whole story from the pages, because he didn't want to see me. I hoped to meet him on one of my regular visits to the library because he loved books too and often sought refuge there.

I fell in love with the history of Florence. I started by looking for information on our ancestors from Mugello, then went on to research the birth of the beautiful Fiorenza. How great our city had been and how many brilliant people it had produced! What was it, I asked myself, that had made our land so rich in brilliant minds?

I returned home in 1717, shortly after the death of my beloved Johann Wilhelm, who had passed away the previous year. I took my faithful Maria Vittoria with me. Known as 'Maria', my personal servant followed me like a shadow and knew how to keep quiet, but always listened. These are gifts that I've always appreciated in people. I started my research in the summer, when we were staying at the convent of Quiete in the Careggi hills. Unlike Violante, the widow of Ferdinando who had died four years earlier – this unlucky number is a recurrent feature in our family history – I hadn't been given a villa of my own. I found lots of books in the convent library, mostly on religious subjects. One exception was a copy of the *Historia fiorentina* by Poggio Bracciolini. It gripped my interest so much that when I returned to the city in the autumn, I began frequenting the magnificent rooms of the ancestral library designed by the great Michelangelo for Pope Clement VI, which was next to the basilica of San Lorenzo. I was welcomed there by the great flowing flight of stone steps and then the rectangular room with the benches aligned on the right and the left, where the light reflected off the white walls embellished with cornices in *pietra serena*. I felt at home there, surrounded

I. THE PROMISE

by the sweet and intense scent of the wood. I was always accompanied by the loyal and diligent Maria. She was very serious and I would even dare to say austere. A touch of cheer wouldn't have gone amiss in her. In any case, she was almost perfect. There were no court ladies in that sacred place. They were too frivolous for my 'mission', which was what I called my research.

Sitting alone, in the last row, I used to look through those heavy volumes, yellow with age, some of which were in parchment with magnificent drawings, interwoven with gold. I discovered that Pico della Mirandola and Marsilio Ficino themselves had copied some volumes, or so the old librarian liked to tell me. When my father came to hear of it, he forced me to use a separate room. I was told this was for my own safety, but I knew that it was because a woman, even if she was a princess, was not allowed to access places of learning. It wasn't written anywhere, not even in the Bible, but that was the case and there was no question about it. Cosimo was very religious. The Florentines thought he was a bigot, but I believe his faith was genuine, having learnt it from his mother Vittoria, who was my grandmother and also my substitute mother. I loved her so much! I couldn't and wouldn't have been allowed: Cosimo had had so many arguments with his wife and daughters-in-law, always fighting for privileges and wealth or freedom. He expected me to be obedient and devoted, and so I was throughout my life. However, I did not obey the Austrians and I fought against them to ensure that nothing, including those magnificent books, was taken away. Even after the pact of 1737, the commander of the Lorraine guard and a Swiss lieutenant came one day. They wanted me to give them some of my family's treasures – paintings, tapestries, silverware – at the behest of Francis III of Lorraine. I refused, saying that they would be safer with me, to which they arrogantly replied that only the grand duke could give orders. They wanted to take them by force, but I called my servants and together we managed to drive them away. I, the last descendant of an ancient house and a dispenser of beauties, would not have permitted such brutality. Those uncivilized peasants would have had to pass over my dead body! So much arrogance and rudeness in my house! Only the ignorant are unaware of

~ 17 ~

their condition before art and cannot appreciate the beauties that God has seen fit to bestow upon Florence. Even Maria, who has certainly not received a proper education, is able to marvel at such magnificence. On that particular day, she – who never says anything – actually smiled in pleasure. Perhaps I could involve her more and ask for her opinion, although my rank forbids it and the natural distance that separates the people from the royal dynasty must be upheld between us. In any case, I am growing very fond of her. Intelligence is not measured in blood and Maria has plenty of ingenuity. She doesn't show it, she doesn't flaunt it, and she does well not to. She would stir up envy and resentment in the court, since my ladies don't look favourably upon her.

Those manuscripts in the library, collected by Cosimo the Elder and added to by his grandson, taught me many things about my city. So that I wouldn't forget them and could look back over them when I was away from the building, I wrote them down in a little book that I carry with me at all times and read over and over again, sometimes adding additional notes regarding things I recall from that period of study. Writing has brought me comfort and peace, but above all it has helped me to uphold my city's rights and safeguard its treasures. These words help to mark out a path that, by drawing upon our roots, finds the strength to project us towards the future. I tried through prayer, but prayer serves another purpose.

My father was a handsome man. Tall, with large eyes, full lips – they say that I look like him. We certainly have similar eyes and determination. My black curly hair is from Marguerite, my lady mother. My father also loved art and added to the Uffizi collections with portraits by famous painters, statues brought from the Villa Medici in Rome, such as the *Venus*, the '*Arrotino*' and the *Wrestlers*, and lots of classical busts from the Boboli Gardens. Cosimo loved walking along those corridors to admire the treasures. Unfortunately, during his final years, when he was bitter and tired, he locked up the art and science collections, the manuscripts and the library – alas! – so that Antonio Magliabechi went around saying that culture had been buried.

My lord father's only concern was the end of the grand duchy. He did not want it to finish up in the hands of others and so, in 1713, he issued

a decree that sanctioned my succession. Upon my death, the city would then go back to being a republic once more. But they did not allow it... They said his words were 'the ravings of an old madman'. Without even going to the trouble of invading us, the European powers decided that the decree wasn't worth the paper it was written on. My father realized that it was all over and that perhaps a real prestige had never existed. He was disappointed, tired and old, comforted only by my presence, his daughter who had returned to Florence. This is why I felt obliged to do as much as I could to avoid the profligacy that was threatening our collections and our monuments.

Lily [*Lilium*], in *Herbarius Moguntinus*,
Mainz, Peter Schöffer, 1484, pl. 77.

II. Origins

Florentia antica

A city's origins are often shrouded in mystery. Florence does not have a founding myth such as the tale of Romulus and Remus in Rome, and there are no heroic actions associated with its birth.

The Etruscans preferred Fiesole, which benefitted from a very secure location. However, when Caesar's soldiers arrived, they decided that the confluence of the Mugnone and the Arno would facilitate movements of troops and supplies and so they settled there, building their camp.

– This was the time of the *Ludi Florales*, the ancient games celebrated in honour of the goddess Flora, and so the name that was most congenial to her and auspicious was *Florentia* (hence the old name 'Fiorenza'), the city that flourishes.

– Of course! Like spring, Princess, full of colour and a joy to look at.

– Maria, if it's true that names can guide our destiny, then for Florence it must have been the flourishing arts, which shone more brightly than in any other city apart from the Athens of Pericles, that led to such a propitious season. A real spring. The Renaissance was born here, during the time of my ancestors, Cosimo the Elder and Lorenzo the Magnificent.

And so the Romans marked out the cardo and the decumanus, starting from the Forum which was where the Mercato Vecchio is today.[1] Via Calimala, which runs from north to south, formed the decumanus.[2] While Via degli Spaziali and Via degli Strozzi, divided in two by the Forum, run from east to west and formed the cardo. In the centre of the Forum they erected the Column of Abundance, and then they marked out the other roads with great precision, forming a kind of grid. The camp grew to become a city with a port on the river and an amphitheatre, baths, temples and houses inside the first circle of walls.

The ancient Florentia stood on a strategic point along the important Via Cassia, which explains why the Etruscans from Fiesole also made their way there. They mixed with the Romans and benefitted from the added trade and traffic. The great Dante despised them in reality:

> Old fame in the world calls them blind,
> a people avaricious, envious and proud;
> see thou cleanse thyself from their ways.
> …
> Let the Fiesolan beasts make fodder
> of themselves and not touch the plant –
> if on their dung-heap any yet springs up.[3]

What would the Poet say today if he saw how his city was reduced and into the hands of which foreign powers it is falling!

– So the glories of the emperors passed away, and the Ostrogoths led by Radagaisus laid siege to Florence in 405, devastating the surrounding lands. However, they were eventually crushed by Stilicho, general of the Late Roman Empire, who was scornfully described as *semibarbarus*. In reality, reports tell us that the Ostrogoths were defeated by hunger. With only figs and olives to eat, they ended up exhausted by dysentery.

– What a sorry state of affairs, Princess! –, and Maria blushes, inclining her head.

– Yes, the Florentines can always be irreverent and salacious, even when it comes to battles. And while warcraft is hard yet exhilarating, work in the fields is just plain hard. Perhaps this is why our ancestors devoted themselves to trade and industry. On this occasion, the city, which was originally dedicated to Mars and then become Christian in the 3rd century thanks to St Minias, erected a shrine dedicated to the martyr, buried on the hill that bears his name.

– Apparently, the beheaded saint dragged himself up the mountain carrying his head in his arms. Is this true, Princess?

– That's what my father Cosimo always said and he really believed it. In fact he kept some precious relics. All I see is the beauty of this very old church, with its sharp, geometric shapes, standing out in white amidst the green and blue.

Along came the Byzantines and then the Lombards, converts to Christianity and lovers of saints too, especially St Michael, because he is traditionally depicted holding a sword. They built a church with a convent and a garden, which were later destroyed. But this land was the site of the Orto di San Michele, known as Orsanmichele, where wheat was stored: saints and commerce united for the future of Florence. For a while, the industriousness of the Florentines was limited because the most important route leading from northern Europe to Rome was 'diverted' and passed through Lucca.

– But even this misfortune failed to 'divert' our ancestors' love of commerce? – interjects Maria.

– That's right. The Florentines continued on their path to riches. The Franks came. Charlemagne visited us three times to our great honour, even though the city had lost much of its importance over the course of those centuries. Thus it went from dukes to counts.

– Different names for the same thing! Lombard dukes and Frankish counts.

– That's very true, Maria. In fact, things didn't change at all. A turning point only came with Emperor Lothair. In 854 the counties of Florence and Fiesole were united, to the benefit of our city.

– Its goodness and our gain. Isn't that right, Princess!

In Giovanni Villani's *Cronica* I have read and deduced that Otto I of the house of Saxony, an ancestor of my sister-in-law Anna, was the man who first granted us a certain autonomy, at the expense of giving more power to the clergy, or rather the bishop.[4] The sign of freedom in the name of Christ, before then duly distancing himself from the Church. But one thing at a time: the Hungarian invasions that followed led many peasants to move inside the walls that were then expanded, following the outline of the Roman walls and incorporating the hamlets that had been left outside. It was the third circle, known as the Byzantine walls.

"This millennium and no more" the wise men said, and when the worst was feared, darkness and trumpets announcing the end of the world, the dawn of the new day dawned merry and bright, and men and women woke up happy. Perhaps other factors played a part too: a milder climate, the growing population and better farming techniques. Whatever the case, the world changed drastically and those dark centuries were left behind. Florence was able to benefit from its favourable geographic location and the revival of trade. It chose the right side in the struggle between Pope Gregory VII and Emperor Henry IV, supporting Countess Matilda of Canossa, an ally of the pontiff, for the reform of the Church that was too corrupt and far removed from evangelical principles. It was during this time that the fourth circle of the city walls was built, known as the 'Matildine' walls, which extended all the way to the Arno with a fortified castle. After a ten day siege, Henry was forced to withdraw and …

– And in order to be pardoned by the pope, who had excommunicated him, he covered his head in ash and went to show his repentance at Matilda's castle for three days. Everyone knows this.

– In fact, dear Maria, Florence obtained numerous privileges granted by the countess for the help it had given to the pope.

When he died in 1115, the Commune could be said to have been constituted and from this moment on, the independent history of what

would later be the Florentine Republic began, but internal discord also started and factions went to war against each other. This didn't prevent the city from becoming the most important European emporium of the 14th century. Meanwhile, the Commune filled up with taller and taller towers, demonstrating the importance of the families who lived there. Pride and arrogance spread everywhere. Towers were joined to houses and enclosed courtyards to form veritable castles within the city, united by consortia, kinships and friendships between families.

– The towers were often laid to siege and demolished. And then they were rebuilt. Did you know, Maria, that you can still see the holes for the wooden scaffolding to be erected and dismantled quickly. In other words, the lords went into hiding while maintaining their warrior attitude.
– I'd noticed them, but I'd never realized what they were for.

There was very little space inside the walls. The streets were small and winding so that it was possible to shelter from the cold and rain, only allowing a small amount of light to filter through the windows of the houses. The numerous overhangs, facing outwards, were useful for enlarging the spaces. In this warlike climate, there was obviously plenty of thought about destroying other cities, including the neighbouring enemy city of Fiesole. The Florentines also saw the saints as armed warriors who were not only able to look after the faith, but also to help them against their enemies and symbolize the greatness of Fiorenza with every means available to them.

During this period, under the pretext of a failed marriage between two important families, divisions started to form between Guelphs and Ghibellines, with the former allied to the pope and the latter to the emperor. And for a year, the two consuls at the head of the city were to be replaced by the *podestá*, a foreign legal expert who would guarantee impartiality and be accountable to the council.

With the development of the city's economy, the 'new men', that is to say the artisans, merchants, bankers, judges, notaries, apothecaries, and all those who derived their wealth not from land but from work and the

accumulation of money, had already begun to press for access to government, and obtained a new magistracy, the Captain of the People, charged with protecting their interests against any arrogance or abuse by the nobility. The people's victory was complete when the guilds, into which it had organized itself, took command of the city.

Meanwhile, a new conflict had arisen between the communes and Frederick II, grandson of Barbarossa, Emperor of the Holy Roman Empire and also heir to the Norman kingdom in Sicily on his mother's side. Frederick II was immensely powerful, but this wasn't enough for him to withstand the revolt of the communes, including our city of Florence. Frederick was defeated in this war that lasted thirty years, but the conflict only reached its definitive end upon his death in 1250.

– Princess he is spoken of as the antichrist, a heretic and a ruthless man.

– No, he simply contested the primacy of the pope over the emperor. He was a great man, a scholar, the founder of the Sicilian School – which inspired many of our thirteenth-century poets – and a builder of beautiful castles.

– But is it true that Frederick II avoided passing through Florence because it had been prophesied that death would catch him in a city whose name contained the word 'fiore'?

– So the story goes. But Frederick didn't know that the Capitanata area of Apulia contained a village called Castelfiorentino, and there death awaited him.

Independence from imperial power and the struggle for rights allowed the cities of central and northern Italy to prosper unencumbered, free to enact laws, trade, set up industries, mint money, arm an army and declare war, without asking anyone's permission.

And so began the glory years of the First People, of whom Dante Alighieri speaks enthusiastically, leading to the conquest of other cities: San Gimignano with its beautiful towers, Poggibonsi and Volterra, forcing Pisa, Siena and Pistoia to accept the will of Florence, which was growing ever stronger and more combative, determined to get rid of any

competitor, in order to control trade. Only Siena resisted; every summer, the Florentine army went to ravage the countryside but failed to seize the city, which was well defended within its powerful walls. The Sienese even used poisonous substances, in which they were seemingly experts. But none of this was enough, which is why they still hate us so much. They would be conquered by us many centuries later, in 1555, at the time of my ancestor Cosimo, the first Grand Duke of Tuscany.

Now let's return to the First People who, having taken sides against the Ghibellines, drove them from the city. As the latter took the banner of the Commune away with them, the Guelph banner with the red lily against a white background was adopted instead, going on to become our emblem. In order to better ensure the triumph of the people against the hardened aristocrats, a decision was made to lower all towers to a height deemed fair, which was no more than fifty *braccia* (or arm's lengths).[5] Who knows what the sight of the pollarded towers must have looked like, all the same height, as if a giant axe had sliced the city in half. At the same time, a gold coin was created bearing the effigy of St John the Baptist and the lily: the gold florin, destined to be unrivalled throughout Europe and the Mediterranean in the 14th century.

– And just think, Maria, that now the Germans are buying us for just a few *ruspi*. A grand duchy put up for auction by those who were once subject to the laws of our merchants and borrowed from our forefathers in the form of sealed florins.

– What does that mean, princess?

– Gold coins contained in a bag bearing the seal of the Commune, so that they couldn't be counterfeited. So history goes: formerly powerful peoples fall while others take their place and prosper. But art can't be put up for auction. It's the heritage of the place where it was born and of the forefathers who created the statues with their chisels, the paintings with their brushes and colours, and everything with ingenuity and study: I'm thinking of the great Filippo Brunelleschi and his dome. Naturally, they can't take any of that away from us, but what about the rest? I must oppose this destruction.

Maria is humble but ready and very sensitive; she often points out the most beautiful things right in front of me, that I've never noticed before. I'll confess to her at the right time. Perhaps I put too much emphasis in my speeches, but I see that she follows me spellbound. It's just a pity that she wears such austere, dark clothes ... she should make the most of herself. After all, she's still a beautiful woman, despite her age. But there is something that escapes me, she seems to want to demean herself. Who knows!

But those wonderful days of the First People didn't last long and the difficulties began again for our city when Manfred, Frederick II's natural son, decided to gather the forces of Ghibelline allies, including Pisa and Siena. In Florence, the Commune refused and by force of circumstance switched to the Guelph side, driving out the Ghibellines, including the great Farinata degli Uberti, whom Dante describes to us as follows:

> and up he rose – his forehead and his chest –
> as if he had tremendous scorn for Hell.[6]

The extraordinary power of the Commune enlisted an army to overthrow Siena, with which it had resumed its rivalry. In the meantime, Manfred reunited the Ghibelline forces with the Pisans, Sienese and the outcasts, and on 4 September 1260 the Florentine army was annihilated at Montaperti. This was followed by "the carnage, the great bloodshed that stained the waters of the Arbia red".[7]

Count Guido Novello and Farinata rejoiced, but when Manfred, a worthy descendant of Barbarossa, decided in Empoli to raze Florence to the ground as he could no longer place any trust in the city, Farinata rebelled. And it was he alone who defended it openly, as the Poet says. Despite the affront he suffered for the love of his country, he declared that he would protect it to the end, with weapons clenched in his fist.

– Maria, you see that the Florentines know how to be factious, vindictive, ready to drive out their opponents only to be driven out in turn.
– Princess, there is no worse revenge than forgiving the insult ...

– Unfortunately, the world doesn't work like that. In any case, the Florentines are also endowed with a passionate love for their city: they all want to live within its walls, among those houses and palaces, to re-build them in an even more sumptuous fashion, to erect churches and bell towers and to proclaim on the inscriptions of the buildings that it is and must be the most beautiful and richest city in the world.

Just like my ancestors, I've inherited that pride too and I want to save the collections from ruin. They need to remain here, where I'll be buried with my ancestors, in the church of San Lorenzo. I need to take steps to complete its mausoleum in order to close the circle. Even if there can't be a vertical line of descent, there should at least be a circle representing the perfection of an ac-complished design. The balls that symbolize our family. Five red bezants and one blue one ... Some call them pills, others bitter oranges in reference to our trade with the East. What is more likely is that they took the gold bezant, the symbol of the Arte del Cambio, the bankers' guild, which my family had joined after moving to Florence from Mugello.

The Guelphs returned after six years and this time it was for good. In fact, they created a magistracy, the Order of the Guelph Party, de-signed to guarantee their position. Its captain took the place of the Cap-tain of the People. More exiles, more blood, fire and destroyed houses. And then it was back to conquering Tuscany again. The Republic, now at the head of a new Guelph league against Ghibelline Pisa and Arez-zo, saw Pisa defeated by Genoa at Meloria and the Aretines beaten at Campaldino. In the meantime, a change had taken place in the parties – that of the magnates and nobles, and that of the merchants and arti-sans (*popolo grasso* and *popolo minuto*) – who had organized themselves into the major and minor guilds. The priorate was established, which would govern the guilds for two centuries. In order to take part in po-litical life, the magnates had to belong to a guild. And, between 1293 and 1295, Giano della Bella's famous Ordinances were promulgated. At first, they declared an absolute ban on the city nobility from assuming public office, but the measure was subsequently relaxed, allowing the

nobility to be involved as long as they were a member of one of the city's guilds. The merchants, who were now masters of the government, had won, along with Giano, who had turned himself into a popular magnate for the sake of justice. However, Pope Boniface VIII, sadly made famous by the slap in the face he received in Anagni, came to break the eggs in the basket ... I'll come back to him later.

With Maria, we stop in front of the cathedral on our way back to the palace in the carriage and observe the magnificence of the baptistery.

The baptistery is one of the oldest churches in Florence and, together with Giotto's beautiful bell tower, it echoes the white and green of the oldest Florentine tradition, which can also be seen in the facade of the basilica of San Miniato al Monte. The lozenges of the bell tower with the seven planets, located on the west side, would appear to be unrelated and instead represent alchemical symbols. Thus, the images on the tiles are nothing more than operations of the same type to obtain the philosopher's stone, the same stone that the king in the central tile holds out with his right hand. The bell tower therefore symbolizes the axis of the world that unites heaven and earth.

Dante's peers knew that the baptistery was an older building, perhaps dating back to the Roman period; a pagan temple transformed into a church. Indeed, much of the marble cladding, as well as the numerous fragments, ancient inscriptions and large columns under the doors inside, come from the ruins of Roman *Florentia*. The sides form a regular octagon. It has eight sides because the eight day represents the resurrection of Christ, an eternal day without end.

The 13th century also saw the start of the interior decoration covering the walls, the *scarsella* (a small rectangular apse) and the entire dome with tiles, by Coppo di Marcovaldo, Cimabue and many others. We go inside and it is here that our attention is captured by the splendour of the mosaic-covered dome, dominated by the huge figure of *Christ the Judge* with scenes of the Last Judgement occupying three of the eight sections.

– Princess, this hell depicted in the mosaic is truly terrible! Satan is devouring one of the damned with his mouth, while two snakes emerge from his ears biting two more figures. It's horrifying!

– Don't be too frightened! It's just an image and in fact it was created for this very purpose: to arouse fear among the faithful so that they did not end up like this.

To complete the sense of beauty and perfection, the monument was also embellished with three splendid bronze doors, paid for by the *Arte di Calimala* (guild of cloth merchants). They look like they're made of gold, because they reflect the sun's rays and this makes them shine. We leave through the East Door, created by Ghiberti, which Michelangelo described as the 'Gates of Paradise'. Not only was it worthy of Paradise but whoever came out of there, after receiving baptism, entered the cathedral of Santa Maria del Fiore, that is, the Kingdom of God.

– Look how tall the bell tower is! It was designed by Giotto. Don't worry, I won't take you up to the top. My legs don't bear me as well as they used to, but as a child Uncle Francesco made me climb all the steps. I was with Gian Gastone and from up there we could see the roofs, the sky and the high clouds, but above all the dome. It felt like we could touch it. We were so happy then, dear Maria!

Suddenly a black cloud covers the sun and a shadow is cast over me too.

– Princess, don't be sad. There was nothing you could do for your brother. He was very sick. You need to continue with this task you have taken on for the city. You're the only one who can do it, with your determination.

The simplicity of her words reassures me and we return home happy thanks to that day spent in harmony with creation, surrounded by books and monuments. Her discreet presence is like a balm, a sip of cool water in the desert.

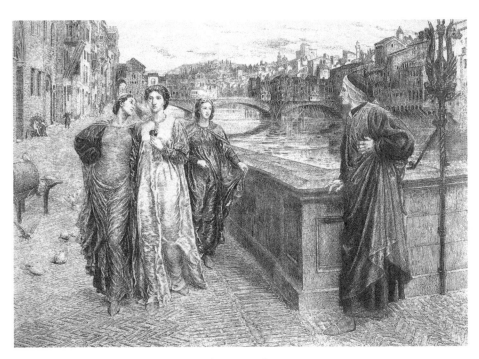

Dante and Beatrice's first meeting.

III. The 14th Century

Merchants and bankers

The harmony desired by Giano della Bella didn't last long. In 1295, the followers of Corso Donati (a member of one of Florence's most illustrious families, referred to as the baron due to his proud and arrogant ways, who was already in exile because it was feared he wanted to seize power), known as the Donatists, accused Giano of being a subverter and summoned him to face trial. They were supported in this by Boniface VIII. Not only did Giano fail to appear before the court that was to judge him, but he exiled himself. The Ordinances withstood and the government remained in the hands of the Major Guilds, but the Guelphs were once again divided into Whites and Blacks. The Blacks were headed by Corso Donati and the Whites by Vieri de' Cerchi.

While the Whites believed firmly in the city's independence, the Blacks didn't hesitate to seek the pope's support in order to achieve total control. And it's at this point that we meet him, the Poet: Dante Alighieri, whose full name was Durante, from the ancient Alighieri family, which was proud but lacking in means. In order to participate in the city's political life he had become a member of the *Arte dei Medici e Speziali* (guild of doctors and apothecaries), despite not exercising this profession. Due to serious political incidents caused by Boniface VIII who

wanted to take over Florence, when Dante was elected to be one of the priors he seems to have taken an important measure in order to avoid further bloodshed: he decided to remove the most sectarian members of each group from the city. They even included his friend Guido Cavalcanti, the poet of the *Dolce stil novo*, with whom, in the sonnet *Guido, i' vorrei che tu e Lapo ed io*, he expresses his desire to cross the seas on a vessel together with Lapo Gianni and three beautiful women to talk about love and be happy. Nevertheless, he exiled him, and did so in order to remain impartial and ensure the good of the homeland. He hadn't, however, reckoned with the perfidy of Boniface who, promising peace, gave Corso Donati the opportunity to return with an army through the intervention of Charles of Valois, brother of the King of France, Philip the Fair, thus handing over the government of the Commune to the Blacks. They had trusted the pope and the pope had duped them. At that time Dante found himself on a diplomatic mission to Rome. On 17 January 1302, he learned that he had been sentenced to confinement, in addition to payment of a fine and exclusion from public office. He was accused of barratry, or rather illicit gains as a representative of the Commune. This accusation was so intolerable to him that he decided not to come to Florence to exonerate himself. He was therefore condemned to perpetual exile, under threat of death, and confiscation of his assets. He never returned to his beloved city and he learned what it means to be far from your homeland, or rather:

> … the bitter taste of others' bread, how salt it is, and know
> how hard a path it is for one who goes
> descending and ascending others' stairs.[1]

He wandered from court to court, collaborating with the respective lords: the Malaspina, the Scaligeri and the Da Polenta families. Proud of his own worth and jealous of his autonomy, he adapted to his new condition as a courtier, a free man, a scholar and a citizen. Indeed, his greatest wish was always to be called back to Florence to redeem himself from the charges, but above all to see his merit recognized at home. He would

gift us with the immense work that is the *Divine Comedy*, written in the Florentine vernacular, a summa of medieval knowledge, a journey into the three realms of the afterlife: Hell, Purgatory and Paradise. A journey towards salvation and redemption from sin. In truth, he worked so hard, aware of his talent and genius, because he longed for his great fame to inspire the Florentines to call him back here, to the very church in which he had been baptized and which we visited. This never happened and his body was laid to rest in Ravenna.

– What cruel fate was reserved for our greatest poet! And how he suffered over the condition of his Florence!

– "Ah, abject Italy, you inn of sorrows, / you ship without a helmsman in harsh seas, / no queen of provinces but of bordellos!",[2] I am reminded of his most sorrowful verses on the condition of his homeland. After the murder of Corso Donati and the expulsion of his men, the political situation calmed down and today, dear Maria, we will read something in the library about those dangerous but artistically fervent years.

From Palazzo Pitti we head towards the Duomo in the carriage. We cross the Ponte Vecchio with its perching hovels, then Por Santa Maria with its beautiful shops selling precious goods. Palazzo della Signoria appears to us in all its magnificence, with its tower stretching up to the sky. It was there that councils met, there that citizens practised the art of politics, when they were not busy exiling and killing each other. And then Via Calimala.

– Dear Maria, this is where the greatness of the Florentines began, home to their oldest art: importing woollen cloths to finish and dye them.

The Florentines: adventurous men, ready to travel to foreign countries and face difficulties and dangers of every kind. In time, they began to produce the woollen cloth themselves with a very complex industry based in four areas, called 'convents'. One example is the church of San Martino, built in 1479 by the confraternity of the same name: the warehouses with their high spurs had long since sprung up around it.

– We've reached the Mercato Nuovo, where the money changers kept their wares on stalls covered with green cloth.

My Medici ancestors were bankers and were also involved with the *Arte della Lana* (wool guild). Cosimo the Elder was an extraordinary businessman. His father, Giovanni di Bicci, had already accumulated a considerable fortune. And then here, at the Mercato Vecchio, we can still see the stalls of the fruit and vegetable sellers, and the butchers, who sold mutton and pork. It all looks a bit neglected now and some of the stalls are empty. Florence is no longer the capital of the world. We'll come back on foot one day and I'll show you its most hidden areas, but we'll have to dress like peasant girls so as not to be conspicuous.

– Here we are in Piazza San Lorenzo. We're almost at the library.

– But wouldn't it be easier, Princess, to have the books brought to the palace?

– Of course, Maria, but I really enjoy looking through the books and choosing for myself. I might even find a little gem – perhaps an original manuscript by Boccaccio, letters from Machiavelli or even the autograph version of Francesco Petrarch's *Canzoniere*. Wouldn't that be wonderful?

– Well, I hope you do Princess. I've noticed that you are calmer when surrounded by books, and this is important.

We find ourselves in front of the flight of steps designed by Michelangelo. It starts with three ramps divided by a balustrade, which reconnect at the top to form a single landing leading to a single ramp: a bold construction that anticipates the Baroque style. My dress trails behind me and Maria lifts the rustling silk to help me as I climb. But a moment of hesitation on her part causes me to trip. The valet following us promptly prevents me from falling. Maria is mortified and fears being reprimanded, but chases away the valet with a confident frown. The librarian arrives all solicitous and tells me that I don't need to go upstairs, he'll bring the books down to me. I don't even reply. Treating me like an old woman irritates me and so I continue on my own, without assistance. I look at him with disdain. "I want to choose my own", I reply. "I'll tell you

if I need anything. Move aside, quickly!" Everyone leaves quickly without a word, including Maria who waits for me in the vestibule.

The Florentines consider me haughty and contemptuous, yet when they have a favour to ask, they are solicitous and I generally oblige. Gian Gastone used to say that Florence had three madonnas: one of sorrows, Violante, Ferdinando's wife; one of milk, the fat Eleonora Gonzaga, widow of his uncle Francesco; and the third of graces, that is me, the Electress.

On my own in the little room that is always reserved for me, I look at the books I'd left on the table.

In Villani's text, I read that in around 1336, out of a population of 90,000 inhabitants, as many as 30,000 were employed in the workshops and that the *Arte della Lana* had more than 200 employees and produced up to 80,000 pieces of cloth.[3] This was a complex process involving several stages before achieving the dyed and finished product, ready for sale. You can still see the somewhat peripheral fulling mills on the riverfront, where the fabric was fulled, and the *tiratoi*, which were covered terraces where the cloth was dried. There were numerous dyers in the Santa Croce area, where the name of the Corso dei Tintori can still be read today. The wool merchants were certainly the richest of entrepreneurs. The Major Guilds also included Judges and Notaries, merchants of Por Santa Maria (who belonged to the *Arte della Seta* or silk guild), Doctors and Apothecaries, Skinners and Furriers, and naturally Cloth Merchants and Money Changers. The Minor Guilds included Armourers and Sword-Makers, Cobblers, Shoemakers, Bakers, Woodworkers, Winemakers, Hoteliers and other activities, which were less important but still contributed to the greatness of the city, which owes everything it has to the ability of its merchants and craftsmen. After all, artists are simply artisans who have perfected their skills. Of course, genius stands out and shines in some, but that genius has been accompanied by industriousness, craftsmanship and long years of apprenticeship in the workshops of the most famous painters, all the way through to the opening of their own. Leonardo da Vinci himself worked as an apprentice for Verrocchio. And this was also true of Giotto, whose

talent was discovered by Cimabue while drawing a sheep on a stone, up there in the Mugello mountains.

I have to take Maria to Santa Croce one of these days. Having lived in Mugello and then with me in Germany, she doesn't know Florence well. She's spent all her time at Palazzo Pitti and I've never thought of taking her to visit the city as we've done over recent days.

Florence was splendid and strong at the beginning of the 14th century, its economy flourishing. In 1321 it opened the Studio Fiorentino, its own university, which put it in competition with the older and more famous one in Bologna, founded in 1088. Unfortunately, from a military standpoint, it was no match for its enemies and was defeated in several battles: at Montecatini (1315) and Altopascio (1325) against the Ghibellines who were outside the city. But the real loss was caused by the failures of the banks that lent money to the kings of England and France and also to the pope, who had moved to Avignon during that period. What's more, the Florentine bankers – the Spini, Frescobaldi, Bardi, Peruzzi, Mozzi, Acciaiuoli and Buonaccorsi – had until then taken advantage of the opportunity to sell their manufactured goods in those faraway countries where they had branches of their bank.

The most disastrous collapse was that of the Bardi and Peruzzi families. And on that occasion Giovanni Boccaccio returned from Naples to Florence, called there by his father who was employed in this sector.

– Sooner or later, Maria, I'll talk to you about this great writer who was a merchant and often recorded the stories he heard around the place. Magnificent and true tales, but also truly enchanting fables.

Due to these failures, the entire Florentine economy felt the effect of the enormous losses, with many being left without a job because the merchants no longer had the money for their businesses and the workshops came to a standstill.

In order to resolve the situation, a decision was made to entrust the government to the Duke of Athens, Walter VI of Brienne, a French nobleman whom the magnates relied upon. His policy, however, was in favour of the less well-off classes whom he tried to help, partly in order to create a political support base for himself. Feeling that they were backed up, the *Ciompi*, who were paid employees of the *Arte della Lana*, rose up against their masters to increase their miserable wages. The Duke of Athens was driven out by the magnates, but this didn't prevent the workers' revolts, such as the one headed by Ciuto Brandini. The uprising was short-lived and, of course, Ciuto was tried and beheaded, but his struggle would be an example for the popular rebellion known as the Ciompi Revolt that would break out thirty-three years later.

Meanwhile, thwarting plans and projects for political growth and expansion, and snuffing out the lives and hopes of men and women, old and young, rich and poor, powerful and obscure, a terrible epidemic struck Europe: the Black Death. Boccaccio told us about it over the course of painful pages. The disease was carried by ships from the East, from the Genoese colony of Caffa, on the Black Sea. There were rats everywhere and the first deaths began to occur shortly afterwards.

– Apparently, the Mongols had catapulted corpses into the besieged city. The most obvious symptom of the disease were boils on the body: in the groin and under the armpits. People's fever rose and the boils burst, leaving a black mark. The plague spread rapidly and over a third of Florence's population died. There were no effective remedies.

– Wasn't there any way of saving oneself?

– The only salvation could be found by moving away from the city, like the ten protagonists of Boccaccio's work: three men and seven noble and gentlewomen, who shut themselves up in a villa near Settignano. There they spent time making up stories, for ten days, hence the title: *Decameron*.[4] The tales tell of love, merchants, pranks and well-known people from Florence. The work is dedicated to women who suffer greatly from the pangs of love. Indeed, according to the author, young girls can find relief by reading because they usually do not enjoy many other distractions.

– The Guido Cavalcanti novella is set next to Duomo and tells how he nimbly passed the tombs on the side of the church, making a quip to rebuke the group that was mocking him.

– So you know Boccaccio's short stories? You don't need me then, although I'd enjoy re-reading them together. They're always wonderful, but you certainly didn't find them in a convent!

– I find these stories enchanting, Princess, and I'd love to hear them in your voice.

– You're an intriguing woman, Maria, as well as an intelligent one. I promise I'll read you something very soon.

The plague proved to be a thunderbolt from which Florence failed to recover, and its activity began to decline. There was a shortage of textile workers, families had been decimated by the disease, and numerous houses and shops remained uninhabited. Thus the area behind the walls, the last circle designed by Arnolfo di Cambio, who had envisaged unstoppable population growth, remained empty. They planted vineyards, vegetable gardens and even wheat fields there, as can be seen from the street names such as Via dell'Orto and Via Il Prato. The new circle of walls was built between 1282 and 1333, fifteen years before the plague of 1348, which thwarted those efforts and destroyed men and capitals. Nevertheless, the walls provided protection for the beautiful monuments, against which the pestilential scourge was able to do nothing.

The failures of the Bardi and Peruzzi families, the looming shadow of the epidemic, and the many deaths left Florence significantly weakened in terms of trade, yet determined to rise again while maintaining the principle of preserving its freedom from foreign armies and powerful families who sought personal power. The merchant bourgeoisie governed once again on the basis of Giano della Bella's Ordinances From this moment on, the groups that emerged had other names: the Alberti, the Ricci, the Albizzi and, naturally, the Medici. They were supported by the *popolo minuto*, having promised to raise their salaries, although these promises were not kept. It was clear that only a new popular uprising could achieve what were now considered rights: better living conditions and

representation in the guild councils. Thus the Ciompi Revolt broke out in 1378 among poor ragamuffins, who were aware, however, of their own worth and the social injustice perpetrated against them.

Florence was at war with the papacy and the costs involved had brought the city to its knees. Unemployment was high in the wool sector, where Florentine cloth suffered from competition from the English market. Driven by hunger and rage against the powerful, a ragged and barefoot carder, Michele di Lando, followed by a large group of textile workers, occupied the Palazzo del Podestà and the Palazzo dei priori, giving rise to three new guilds: Dyers, Tailors and *Ciompi*, meaning non-specialist textile workers. It was a real revolution: the son of a market vegetable seller, who, under the newly created banner of an angel with a sword in one hand and a cross in the other, led the change and wanted three out of nine priors to be appointed from among the representatives of the Minor Guilds. Nevertheless, it was a real regime. After just one month, unable to govern because they were illiterate and quarrelsome, the Ciompi cast prudence aside, despite having been advised to take care by Michele, and were defeated by an army hired by the *popolo grasso*. Michele di Lando, who had distanced himself from the rebels, was removed, appointed captain of Volterra and then exiled to Chioggia in 1382; Salvestro de' Medici, who had supported them, was exiled on charges of tyranny.

– So, 100 years after defeating the nobility, the *popolo grasso* also got rid of the wage earners and artisans and established an oligarchic government, headed by the most important families…

– But, Princess, how could they be sure of those who had been elected?

– It's simple: by controlling the names of those who were placed in the bags or 'pockets' to be elected among the priors, choosing only friends and exiling those who showed too much ambition and power. By doing so, the few ruling families were absolutely certain to get their decisions through, knowing that there were only allies to be found in the pockets from which they drew by lot.

As always, the balance of the oligarchy is based on a policy of active expansion. In order to prevent the Visconti, lords of Milan, from conquering central Italy, Florence subjugated Arezzo and Cortona. However, the most significant event was the conquest of Pisa in 1406. Florence, which did not have free access to the sea, finally inherited the Pisan fleet and the annexed ports, thus adding the missing piece – maritime and colonial power. Thanks to the Pisan galleys, the Florentine companies opened branches in the major Atlantic ports, and also in Seville, Lisbon and Rouen. Goods from our workshops were unrivalled and unheard-of geniuses and talents arrived in the city. Already a wonder of the medieval world, Florence was enriched with new treasures, rediscovered the classics, reinvented forms and raised the huge dome as a symbol of its greatness. The intellectual and artistic capital of the known world, it placed humankind instead of God at the centre of its interests, marking the start of Humanism. It's no coincidence that Boccaccio's *Decameron* anticipated this by representing the human comedy as opposed to Dante Alighieri's *Divine Comedy*.

During this period, the most important centre of power was the Chancellery of the Republic, where diplomatic relations were forged. Numerous letters were written there as a result. It was first directed by Coluccio Salutati, famous for his commitment to the new cultural orientation that saw humankind at the centre of interest; then came Leonardo Bruni and Poggio Bracciolini. Tied to a strong civic ideal, they considered cultural activity as a commitment to city politics and did not consider themselves to be in the service of any power but themselves, in the name of Florence. Leonardo Bruni wrote in 1436 that Francesco Petrarch "was the first, who had so much grace of wit, that he recognized and revived the ancient gracefulness of the lost and extinguished style".[5]

– Maria, you look at me and don't understand the style I'm talking about. It's Latin, the language of the classics, especial Cicero and Virgil. It's not medieval Latin.

Petrarch himself searched monastery libraries for ancient, forgotten or neglected works, and asked friends to help him too. He discovered Cicero's letters, drawing inspiration from them and imitating their elegant style. This research led to a new intellectual approach for the humanists. Classical culture was not just something to be preserved, but to be explored in the quest for new paths, as part of individual research on human values. Opposing stylistic tradition to *come upon*, or 'discover', something new, to invent what was not there. The artists experimented, wrote treatises, discovered new techniques and revived old ones. Lorenzo Ghiberti, Piero della Francesca, Leon Battista Alberti, and many others, all the way through to the great Leonardo da Vinci. The workshops of the artists, painters and sculptors had always been centres of art and culture, and would continue to be so on an even bigger scale. Even in barber shops it was not unusual to hear people discussing art and declaiming Dante's verses. Many of them were in the vicinity of Piazza della Signoria, close to the political centre, so that they often came to hear about indiscretions and gossip.

Meanwhile, there was fervid creative activity in the workshops of the painters. They selected poplar planks cut closest to the pith, then mixed plaster with glue and applied it to the planks. The boiled bones used to make the glue filled the air with a real stench. Pigment grinders died young and had a blue tongue due to the effect of mercury. Milk and curdled casein were obtained from goats, providing the best tempera for painting. The *battiloro* (gold-beaters) reduced gold to leaf form by beating it on an anvil. Everything revolved around the master painters who gave orders and produced masterpieces for the rich, but also for the poor who admired them, enchanted, in the frescoes of the churches.

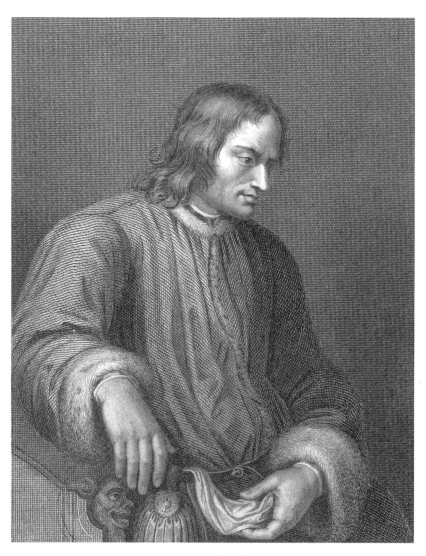

Lorenzo the Magnificent.

IV. The 15th Century

Renaissance

I speak out loud these verses by my great ancestor, Lorenzo the Magnificent, who composed them during the 'Carnasciale',[1] while the floats were parading:

How beautiful is youth
that nevertheless slips away!
Whoever wishes to be happy, let them be:
for there is no certainty of tomorrow.
Here are Bacchus and Ariadne,
beautiful, and ardent for each other;
because time flees and deceives,
they always remain content together.[2]

My pot-bellied uncle would always recite them to me and make me dance to the sound of the tune in the ballroom of Palazzo Pitti. And I would laugh, watch my uncle dancing with me in his cardinal's robes, awkward and uncertain, and feel cradled in his arms and lulled by the music. But that obsessive, rhythmic refrain contained melancholic notes that I didn't understand at the time: we can't stop time, we can only delude ourselves into doing so and in the deception we are happy, as if we had a magic potion at our disposal.

So play, dance and sing,
Let your heart burn with sweetness:
not toil or pain!
What must be, let it be.
Whoever wishes to be happy, let them be:
for there is no certainty of tomorrow.[3]

Yet the beauty of artworks remains and does not age: art holds the secret of eternity. And we have had such an abundance of it, such a concentration of it ... as if God had poured a shower of gold and emeralds over this city in handfuls, a river in flood.

– But Princess, why did God want to favour Florence more than any other city, particularly as it was home to so many bankers and usurers?

– I see, Maria, that your intellect is growing sharper. You ask some very clever and pertinent questions. It's true that my ancestors were usurers too, but then, perhaps in order to apologize to God, they built convents, hospitals and churches, and so did the Rucellai and other great families. This was particularly the case in the 15th century, which was the century in which the Medici appeared on the scene and then became lords without a title. In any case, I don't believe that their fortune depended on God, but on human actions, as the humanists claimed.

– Princess, it's often the case that as fortune takes away, so she gives, and as she gives, so she takes away.

– But humans are the arbiters of their own destiny. When he was still in his early twenties, Donatello sculpted his marble *David*, a boy who kills Goliath with a sling. It was this biblical David who became the symbol of the young Florentine Republic that had defended its freedom with the same courage and pride. Donato di Niccolò Bardi, the son of a modest wool carder, was a friend of Cosimo, the grandfather of the Magnificent, the first lord acclaimed by the people. As you see, art united the lords with the humble if they were gifted with genius.

IV. THE 15TH CENTURY. RENAISSANCE

One of Cosimo's ancestors came from Mugello, probably from the Cafaggiolo area. His name was Salvestro de' Medici and he was possibly a timber merchant. He moved to the Mercato Vecchio district, where he continued his business among merchants and commoners. As we know, he aided the Ciompi Revolt and was exiled, but the family did not shy away from this: they had already collected fines and sentences. In the early 15th century, while the aristocratic Albizzi family dominated, keeping possible riots and tumults at bay, Cosimo's father, Giovanni di Bicci de' Medici, a daring head of the Medici Bank, with branches in the major Italian cities, financier of popes and princes, made his way into the limelight. He was the richest man in Florence after Palla Strozzi, and one of popular origin to boot, given his ancestor's contribution to the Ciompi Revolt. As we know, fortune and success lead to envy and slander, but above all the fear of losing the position of supremacy, which at that time belonged to Rinaldo degli Albizzi. In order to raise money to support the wars and gain consensus, he had a fairer tax reform adopted in 1427, known as the 'catasto' (land registration). Giovanni had obstructed this reform, which affected the wealthiest citizens.

– What does that mean, Princess? I don't understand anything about taxes and levies.

– Dear Maria, quite simply, as I have read and seen with my own eyes, each citizen would present sheets recording their property in terms of houses, shops and businesses. The values were calculated on this basis. Then a percentage to be paid to the Republic, minus expenses, was established. Easy! And how they complained, in those sheets for the *catasto*, about being poor, about having no money to pay… But there was nothing to be done: the officials were not moved and people had to pay. Paying to support wars and building activities.

Giovanni died in 1429, mourned by the whole city. The funeral cost no less than 3,000 florins! Out of the numerous children he had with Piccarda Bueri, affectionately called Nannina, two sons called Cosimo

and Lorenzo had survived, who learned their trade at their father's bank and dealt in commercial transactions. What's more, Giovanni had wisely had them educated in the humanities under the guidance of famous masters, experts in Greek and Latin texts. Cosimo immediately showed great talent and married Contessina de' Bardi, in order to gain good family connections among the 'greats' and make influential friends. He took pains to demonstrate his generosity with rich and poor alike, and helped numerous maidens to marry, paying their dowry out of his own pocket. And he was a patron of scholars and artists, initiating the process of patronage that characterized Florence for many years, fostering a great artistic, architectural and literary renewal, which was continued by his nephew and went down in history as the Renaissance. However, the political and military situation was not the best. Cosimo tried to oppose the useless war that Rinaldo degli Albizzi and other oligarchic families wanted to wage against Lucca. The architect Filippo Brunelleschi intended to flood the town with the waters of the Serchio, but instead the flood overwhelmed the Florentine camp, forcing them to flee much to the amusement of their enemies. "The devil helps make the pots but not the lids, not even for a great architect like Mastro Filippo", the people of Lucca used to say.

In 1433, unjustly accused of having wanted the damaging war in Lucca and of having made himself a tyrant in the city, Cosimo was arrested and locked up for twenty-seven days in the Torre d'Arnolfo, in a cell known as the Alberghetto. There, fearing to be poisoned or sentenced to death, he managed to get in touch – thanks to various payments – with influential friends abroad and to change his sentence to exile, which he served partly in Padua and then in Venice. Having escaped danger, he laughed at the commercial inexperience of his political adversaries who could have demanded a much higher sum from him than agreed.

– Life is worth a whole heap of florins, right Maria?
– Of course, if one possesses them, otherwise the man who has art stands in good stead.

The following year, however, his supporters were granted the priorate. The *popolo minuto*, who had not forgotten Salvestro's help during the uprising, made their voices heard and Cosimo was able to return to Florence. Thus began the Medici Signoria and he became known as 'father of the fatherland'. However, he never neglected business for politics. He was a merchant heir to a dynasty of merchants: he quadrupled the fortune that his father had left him and was involved in city buildings and monuments, such as the convent of San Marco, the basilica of San Lorenzo and the Badia Fiesolana.

A man like him had long been thinking of a residence worthy of his lineage, and so he soon commissioned Michelozzo to design the new palace on Via Larga. However, he didn't want it to look magnificent on the outside, but instead simple and rigorous, so as not to arouse envy and slander. He didn't want to be hated and did everything he could to gain consensus and popularity. He baptized numerous children to establish good relations and poured rivers of money into helping the poorest of his fellow citizens. I don't think it was just out of generosity: he was endowed with remarkable political intuition and knew how to gain peace and consensus, a bit like the Roman emperors who ruled by bestowing *panem et circenses*. The Republic was still alive but he controlled the names of those who could be drawn out of the bags, purging enemies and welcoming friends, as I have already explained and as Emperor Augustus did in Rome. The city was enriched with more palaces, despite the damage caused to many city buildings by the earthquake of 28 September 1453. While they were all competing to show how important they were, Cosimo said to one of his rivals: "You pursue infinite things, while I go after finite things; and you place your ladders in the sky, while I place mine close to the earth, so as not to fly so high that I fall".[4]

– But wasn't he the one who wanted the dome for Santa Maria del Fiore?

– No, that wasn't his doing, because the expenses were borne by the city government.

Even before 1418, the year of the competition, Florence had already posed the problem of how to erect the dome, which was to be the largest in Christendom. The Duomo had been completed, but no written record of Arnolfo di Cambio's design remained, so no one knew where to start. The Duomo of Florence had been left uncovered for more than a century, waiting for someone capable of building its ceiling. It was known for certain that it was supposed to be an absolute marvel. Eventually a competition was announced. Many people took part, including someone who, so the historian Giorgio Vasari tells us, even proposed filling the drum with soil and putting coins inside. According to this extravagant person, the Florentines would eventually empty the debris after the dome was raised with the support of the earth and take the coins.[5] Naturally, his project was not chosen.

The problem continued to be the wooden scaffolding, which was too expensive and cumbersome to reach the improbable height of over ninety *braccia* (arm's lengths).[6] Filippo Brunelleschi, who had observed and studied classical constructions in Rome with Donatello, knew how to do it and presented his project, which was accepted. Again according to Vasari, the Florentines didn't trust him initially because they thought he was too eccentric, and so they placed Ghiberti alongside him. There was a real antipathy between the two men, causing Brunelleschi to prefer working in secret, without telling Ghiberti anything. At one point he actually said he was sick so as to leave his unprepared rival to solve problems,[7] and he guarded his ideas so jealously that he even designed special bricks made out of turnips before turning them into soup so that no traces of them remained.

He had encountered a particular wall-building technique known as 'herringbone' in Roman buildings, which could be employed without scaffolding and without the construction falling in on itself. He eventually convinced everyone and was left to work alone. He built wooden models and tested the Barbadori dome in the chapel of the same name, which went on to become the Capponi chapel, to prove that it could stand on its own.

~ 56 ~

IV. THE 15TH CENTURY. RENAISSANCE

– Princess, how did he manage to erect the dome without scaffolding?!

– With a complicated system, which consisted of a double ring of masonry with a cavity in between: two rotating domes, welded together by the ribs, capable of being erected progressively without collapsing to the ground; one dome inside the other, rising simultaneously along the segments of the octagon. In fact, he used bricks arranged in a herringbone pattern.

– The dome is truly magnificent, and you can see it from all over Florence. Indeed, it seems as though all the city's roads lead here, to absolute centre. A cloak decorated with ermine that protects and envelops us. It is our symbol.

– I can see you're enthusiastic about it, and I'm glad: you're often so thoughtful! Vasari wrote that Brunelleschi was always imagining forms, combinations of forces and machinery, including ingenious devices to hold children in the air dressed as angels and saints[8] in the church of San Felice in Piazza for the feast of the Annunciation.

– Yes, but I don't want to go up there. Don't count on me to get to the top where the lantern is. Even if you order me to, I won't go up. I did that once and I felt like I was suffocating inside that tunnel that went up and up, and every now and then you could see tiny little people down there and it felt like a dark force was pushing me down. Forgive me, but I just can't.

We're still behind the cathedral church. I can see that Maria is looking up, towards the dome, and she seems distressed.

– Don't worry Maria, I won't make you go up if you don't want to. Instead, now that we're here behind the apse, do you see that row of white columns around it, above the drum?

– Yes, I can see it, but it comes to a stop and it looks like it hasn't yet been finished on the other sides…

– That's true, but I don't think anyone will finish it now. After Michelangelo called it a 'cricket cage', work stopped and no one dared

~ 57 ~

to resume it. Perhaps beauty needs something to be left unfinished, as the last works of the great Michelangelo Buonarroti show. But let's go back to Cosimo the Elder, father of the fatherland. He didn't forgive his former enemies upon his triumphant return. Everyone who had hindered and imprisoned him was exiled, starting with the Albizzi and Strozzi families.

– Whoever wants many friends should try a few instead, because friends often become enemies, don't they Princess?

– That's right... So, from Piazza del Duomo we've now reached Via dei Ferravecchi. Let's make our way down slowly as I don't want to be noticed around here. Although I'm using a sort of buggy instead of my eight-horse carriage, you never know whether someone may be seeking revenge against my family even centuries later.

– Princess, that's the palace of the noble Strozzi family. It's absolutely huge and very severe. All the brown stones decorating it make it look like a castle. The owners must have been very rich. Were they bankers too?

– These stones are ashlars. You've seen them on other buildings too, including Palazzo Pitti, which is our home now. If you look closely, you can see that the large and imposing cornice is only present on the facade, indicating that there weren't sufficient florins to complete it. It was a grandiose project, built by Filippo Strozzi, the son of Alessandra Macinghi. I really want to tell you the story of this woman who did so much for her family. I've read her extensive correspondence with her children.

The whole family had been exiled by Cosimo on his return. Her husband died of the plague in Pesaro and Alessandra returned to Florence a few years later. From then on she worked hard to convince the Medici to lift the ban on her sons Lorenzo and Filippo. Her dream was to reunite the family and build a large house to represent them, so she had already started buying the buildings next to hers. This palace is her work too, as she was able to hold the threads of the family together and reconnect with Cosimo, who brought some exiles back for polit-

ical reasons. They included the Strozzi family, who in the meantime had become very rich with their bank in Naples.

During Cosimo's years, there was finally peace in Florence itself, although the city was often involved in external conflicts. Rinaldo degli Albizzi managed to convince the Duke of Milan, a Visconti, to declare war on Florence. The Milanese troops were defeated twice, in 1437 at Barga and three years later at Anghiari. This was indeed a memorable battle, depicted in a fresco in Palazzo Vecchio by the great Leonardo. And in 1504, Michelangelo was also commissioned for the Battle of Cascina. Two very important moments in the defence of Florence's freedom that were to decorate the great hall of the Palazzo dei Signori, built about ten years earlier. The two artists, who were both great and unique, had a very different vision: Leonardo's depiction features a conflict of human forces pitting themselves against each other in a stormy landscape, while Michelangelo chooses the calm before the storm.

– Unfortunately, Maria, I can't take you to visit them because the unfinished works have been covered over. We simply have to make do with what Vasari tells us.

– That's a real shame. I was getting ready to enjoy the two frescoes. And then what happened?

– Cosimo's foreign policy saw Florence allied first with Venice against Milan and then with Milan against Venice. In Milan he had Francesco Sforza recognized as duke by all the most prominent figures on the peninsula. And on this occasion, the Serenissima closed its doors to Florentine merchants, seriously damaging trade.

– Of course, Princess, they felt betrayed after the welcome they had given him during his exile, because "loyalty feeds nits", as the people say!

– That's right. Unfortunately, politics is based on a different logic, and what counts is ultimately what is good for the country, as our Niccolò Machiavelli says. The Prince's moral outlook is not commonly shared, "And so it is necessary that he should have a mind ready to turn itself according to the way the winds of Fortune and the

changing circumstances command him".[9] To those who reproach Cosimo for this damaging war, it must be said that Florence had to do this, it had to change its allies and adversaries according to the situation for the sake of maintaining the balance that was beneficial to the whole of Italy. No state was to become so powerful that it could control the other republics or kingdoms, a commitment sanctioned by the Peace of Lodi in 1454, which came about following the fear after the conquest of Constantinople by the Turks the year before, in 1453. However, this meant that Italy remained divided and Machiavelli's exhortation to the Medici, in *The Prince*, to free Italy from the barbarians, went unheeded and so the barbarians did indeed invade a few years later.

– Princess, if it's not inappropriate, I'd like to ask you to visit the Magi Chapel. I've heard its a wondrous place in the palace that Cosimo had built on Via Larga.[10]

– Of course, it will be a pleasure for me to see it again too. It's one of the few things saved from looting and fires… the owners, the Riccardi marquesses, will be honoured to host us.

As the carriage once again crosses the street leading to the cathedral, then the first stretch of Via Larga, I think back to what I've read about the Council for the union between the Byzantine and Latin Churches that inspired Benozzo Gozzoli in his celebrated cycle of frescoes and made the Tuscan city be spoken of as a 'new Athens'.

By paying a large sum of gold florins in 1439, Cosimo, a Church banker in Rome, managed to convince Pope Eugene IV to move the Council to Florence from Ferrara because he considered the latter to be dangerous due to the outbreak of a plague. Descriptions written at the time speak of a unique opportunity for parades, feasts, balls, jousts, hunts and shows of all kinds. As Cosimo was a gonfalonier, a position he did not hold by chance in that year, he was able to oversee everything with taste, pomp and great diplomatic skills. It was a very important opportunity for him to keep his name and authority high. He spared no expense: he received the delegation in the city's most beautiful palaces and entertained everyone

IV. THE 15TH CENTURY. RENAISSANCE

cheerfully. Following this event, Florence became even richer in trade, but above all culturally, since Latin and Greek scholars met there, driving the study of philosophy and classical literature.

At that point, perhaps the highest in its history, Florence became the capital of Christendom. With the Council, it also embraced the culture of the East, that is, the thinking and science of the Greeks, the geography of Strabo, and Platonism.

Collections of objects, including copies of ancient texts, were sold by the great bookseller of the time, Vespasiano da Bisticci, while the mathematician, astronomer and cartographer Paolo dal Pozzo Toscanelli sought an alternative route to the Indies and his insights influenced later discoveries.

– Here we are in front of my ancestors' palace: rusticated ashlar on the ground floor, and smoother at the top, with this magnificent finished cornice. Here too, as in Palazzo Strozzi, there are no shops, which had been a characteristic feature of 14th-century palaces. Instead, there is open space all around, without the houses leaning against each other and without the confusion of the narrow streets of the central area.

– It wasn't built by the great Brunelleschi, was it?

– No, Cosimo preferred the less innovative and sumptuous design of his trusted architect, Michelozzo. When Brunelleschi found out that he hadn't won, he became very angry and destroyed the designs. He was a very talented man, but very very touchy. Small and haggard, "whose virtue is so great that his soul would be enough to turn the world upside down", Cosimo once wrote to recommend him to the pope.

Sending a valet ahead to warn the Marchioness Riccardi, who bows and scrapes to me over and over again, I decline all invitations and, after brief pleasantries, I climb a wide staircase with Maria, arriving in a room that I do not remember being so dark and cramped. The moment the servants arrive with candelabra, we are breathless as we step onto the polychrome floor inlaid with rare marbles and turn around to admire the fresco.

~ 61 ~

Benozzo Gozzoli depicted the procession of Greeks attending the Council, portraying political and cultural figures of the time and, in the foreground, the most important members of the Medici family. All galloping towards Jerusalem.

– You see Lorenzo at the head in sumptuous robes, wearing a crown. The fabric of his vest is embroidered all over with branches and interwoven patterns, fish scales, bat wings and peacock eyes. He is followed by a host of horsemen from the hills. Look, our people wore tights and decorated vests – two-coloured stockings were a Florentine prerogative. The men from the East wore long robes and strange headgear, from turbans to mitres. And…

– And then I can see all sorts of strange animals: monkeys, camels, cheetahs… how nice!

– Sssh! Keep your voice down a little. We're guests here and the silence helps us immerse ourselves in this fairy-tale atmosphere. Do you see? In the centre of the group is the painter's self-portrait, with his own signature on the hat and perhaps, behind him, his master: a friar named Giovanni da Fiesole, who went down in history as Fra Angelico.

The Magi came from the East, undoubtedly following the Silk Road through the fabulous cities of Samarkand, Baghdad and Damascus. The route was frequented by merchants and caravans of camels, marauders and goods of all kinds, especially jewellery, iridescent silks, gold and silver brocades, pepper, ginger, sugar, brass, spices, gold to paint the fabrics and even the frescoes, as seen here in such opulence. The pope, the emperor of the East and the patriarch of Constantinople, with their respective picturesque retinues, made their triumphal entry on 15 February 1439, and Cosimo wanted to remember it this way and pass it down to those of us who were not there. And every year, on 6 January, the procession with the Three Kings on horseback is re-enacted through the streets of the city centre, with the costumes from the fresco and the laying of gifts at the foot of the crib in the cathedral.

– Princess, this city is a bottomless treasure chest. When you take one out it is followed by a whole string of others and you can't help but wonder and rejoice in them. It would take a thousand years and a

IV. THE 15TH CENTURY. RENAISSANCE

hundred eyes to truly appreciate them all, as we've been doing recently. It's heaven for those who see the supreme good of this world in beauty.

As we leave, the light catches us unprepared and the sun dazzles us, like the brilliance of the fresco that has remained imprinted in our eyes.

– Maria, what did you mean about the good of this world?
– Nothing Princess, except that goodness must also be hard won, just as artists have worked hard to create their works. Even I, who am happy today, have fought my battles. I was told I was obstinate and stubborn and I struggled to obey in the convent, but the sweetness of life always makes us put up with a lot. I don't want to bore you. Let's enjoy this beauty.

We continue by carriage past the basilica of San Lorenzo, the Medici parish church. Here, too, Cosimo spent 60,000 florins on the sacristy, commissioned from Brunelleschi and Donatello in partnership, which was to house the family tombs. Taking the nearest road, we arrive, without descending, at the convent of San Marco, which is forbidden to women. It is particularly admired for the elegant lightness of its cloisters and library, but above all for the frescoes painted by Beato Angelico.

Women were not allowed in here and will never be able to admire the beautiful frescoed *Annunciation*. Cosimo, on the other hand, often stayed here. He had a cell to himself and, perhaps tired of business and political quarrels, he sought refuge there to cultivate the garden or meditate. He often watched the friar at work as he painted at speed, almost as if driven by divine will, rarely touching up what he had done. I don't think my ancestor prayed, as he was a very rational man and his faith was consequently limited to classical liturgy and donations, such as this magnificent convent by Michelozzo. He also had rooms at the Badia Fiesolana, which he had rebuilt at his own expense, using a design by Brunelleschi. Here he created a new library and paid a few dozen copyists: in less than two years he prepared several hundred volumes, all illuminated and decorated to perfection under the superintendence of

~ 63 ~

the trusted bookseller Vespasiano da Bisticci. He appointed the learned Marsilio Ficino, his doctor's son, to direct a Platonic academy.

Everything was going perfectly, but at a certain point his power seemed to be undermined by a private matter that attracted the attention of Florentine public opinion. Antonino Pierozzi, Bishop of Florence, had it in for Cosimo because he considered him a usurer and was waiting for the right opportunity to humiliate him. After a long trial, which captured the attention of the entire city, between one of Antonino's protégés, Lusanna di Benedetto, and the rich merchant Giovanni della Casa, a friend of Cosimo's, who denied having married her, the bishop decided to condemn him as a bigamist. The verdict ascertained that the poor virtuous widow had exchanged vows with the man, had received a ring and all this in the presence of witnesses, including the friar who had celebrated the wedding. So the marriage was valid to all intents and purposes. On the other hand, Giovanni had always maintained that the secret wedding had never taken place and that Lusanna was lying, so much so that he had publicly married Marietta Rucellai.

It was the first, and perhaps the last time, that a sentence had been passed in favour of a woman of humble origins. Cosimo had sought to favour his friend through another parallel trial, but ultimately his political power was out-scaled by the bishop's religious power. It was a snub, albeit a temporary one.

– Oh yes, as they used to say in Florence: "when Cosimo rattled the coins in his purse, Antonino tinkled the keys of the bishop's palace"…

– Surely, Princess, this was to prove that despite Cosimo's money, which he received to rebuild San Marco, he was in charge of people's souls and could therefore decide on the sins to be absolved… isn't that right?

– Yes, exactly. It was a moral slap in the face, but Cosimo was soon able to redress the situation in his favour by appealing directly to the pope, who annulled the bishop's sentence. Political power won out against religious power, and Cosimo was secure in his position as head of Florence, even without a title. He consequently continued to be-

stow favours and aid to ensure his support. There was also a slave girl called Caterina involved in the affair, whom Lusanna had received as a wedding gift from Giovanni and then had to return.

– A slave? How did slavery still exist in such a brilliant age? I thought that was something from Roman times!

– And yet it existed! Even Cosimo had a natural son, named Carlo, by a Circassian slave bought in Venice, a certain Maddalena. The child was acknowledged and directed towards a religious life. In Florence, noble families bought slaves to look after children and the elderly, and also to delight their masters. From time to time they were freed too. In fact, when looking through the family papers I found a document with which a girl was emancipated, "so that for the future she could do her will as any free and faithful Christian can", the deed stated.

Cosimo, a prince who had upheld, at least formally, the laws of the Republic, died on 1 August 1464, at the age of seventy-five. Sadly his beloved son Giovanni had died an early death before him, but he had already identified his grandson Lorenzo as a worthy representative for the future of the Medici. He was succeeded by his other son, Piero, who was ill and little inclined to the art of governing. He made the mistake of immediately calling in the bank's long-term loans. This caused him to be frowned upon and lost him the support of the people, most of whom were indebted small-scale artisans and merchants who were unable to repay the sums they had received. The Medici's enemies felt strengthened and Luca Pitti, who headed Piero's adversaries, took advantage of this: they were known as 'the people of the hill' because the Pitti residence was higher up, raised above the road, while we were 'the people of the plain' because of the palace built on the plain, on Via Larga. History is like a compass needle that has gone mad: where will it point north after us?

It's essential that our survivors don't find the city despoiled of the treasures and beauty built by our ancestors and great men. I'm just a woman, a princess without a kingdom, but I will prove my worth to everyone. Indeed,

women have a hidden strength, but they need to be daring and ingenious over a long period of time to be accepted. I will keep doing it, until I draw my final breath. I will work and scheme for it.

In any case, Piero the Gouty exceeded expectations. He managed to escape an ambush on his way to the villa at Careggi. Having been warned in advance, he changed course and escaped. He later had a Signoria elected that was favourable to him and became more determined, managing to ally himself with the young Galeazzo Sforza against Venice. In 1468, the long fight ended with the victory at Imola and the acquisition of the commune of Sarzana. He showed great ability in the field of trade and was a good patron of the arts, a friend of Marsilio Ficino, with whom he loved to converse. In Lucrezia Tornabuoni he had an enlightened and cultured wife, poetess and valuable advisor. "Those who want to have their way should not be born a woman", said his daughter Nannina, married to Bernardo Rucellai. But her mother still managed to advise her husband and, above all, to have her children educated by great teachers, as well as giving Latin lessons herself. We have been left with numerous witty and clever letters to her husband, illustrating her intelligence but also her common sense.

I remember when I came back from Germany, bringing the paintings from my collection of Flemish and German painters with me... my father Cosimo was happy about it, but he worried about what would happen to them and everything else. I tried to reassure him, but I still didn't know how. I went to live in Palazzo Pitti, in the Volterrano district, on the first floor, where there were sunny windows overlooking the large courtyard. I was very close to my father, who had taken up residence in the halls of the piano nobile overlooking Boboli. He would walk through the garden and visit me every day, even discussing government business. He told me that Ferdinando often went to Venice, a lively and libertine city. His travels enabled him to increase the family art collection, with paintings by Raphael and many others. He was the first in Italy to organize an art exhibition,

*which was held in the cloister of the Annunziata. My father had loved him
very much and had hoped he would father children. A flowering branch for
the Medici's pomegranate tree, to continue sprouting other fruit... How-
ever, there were neither flowers nor fruit from him, as he died sterile due to
a disease caused by his sensuality.*

– But Princess, wasn't Lorenzo the Magnificent appointed by his
grandfather Cosimo?

– Of course. Let's get back to our story, dear Maria. I'd lost myself
in my ramblings for a moment. You want to know the facts and I will
satisfy you. Cosimo couldn't appoint a successor because the Repub-
lic was still standing. He'd observed great talents in Lorenzo – he was
cultured, brilliant and sharp, but he had no business sense and so,
when his father Piero died, he bankrupted many of our companies
abroad, including those in London and Bruges. We almost lost Lyons
too, where the director general Francesco Sassetti, following his exam-
ple, was too attracted to the arts and letters and neglected his duties.

– Lorenzo had been mollycoddled throughout his childhood, when
his grandfather was already master of Florence. Cared for and ac-
claimed at all times, perhaps he didn't really care about money, Prin-
cess, as he was born rich.

– That's right Maria, but he was a great statesman, as well as a po-
et and orator. He received dukes and sovereigns who asked his ad-
vice and, like Cosimo, had managed to be the first among equals in
a Republic. He didn't overturn the traditional forms of the state and,
without taking part in any wars, had asserted Florence's supremacy
in Italy. There was peace throughout his life time: he who held the
scales for the good of our peninsula in perfect balance.

You know, Maria, he'd only just turned twenty-one when his fa-
ther died, and he himself recounts that the elders of the state came
to the house "to lament the situation, and comfort me, that I should
take the care of the city, and the state, as my ancestor and father had
done, which things being very burdensome and hazardous for one of
my age, I unwillingly accepted".

– But why did he agree if he didn't want to and was so young? He could have continued to enjoy himself and occupy his time with books and philosophy...

– That's true. Others in his place wouldn't have taken care of the state, but Lorenzo was an exceptional man and he knew that pretending to be indifferent to power is always a good tactic to be accepted as a gentleman. An act he knew well. Perplexed at receiving the post, like Caesar who refused the crown of Rome three times, he showed that he had learned the art of politics well. The Signoria, the *Consiglio dei Cento* (Council of One Hundred), the *Dieci di Balia* (Ten of the Balia) and the *catasto*, were under his control thanks to a trusted circle of friends in strategic places.

He loved illuminated books in Greek and Latin, and commissioned experts to find expensive and rare volumes that he then had copied. His friend Poliziano and Pico della Mirandola were tasked with founding a public library, but he died before seeing it completed. He perceived Michelangelo's genius when he was still a boy and wanted to give him a room in the palace and a small annuity, as well as the gift of a 'mantello pavonazzo', which is a cloak made from burgundy red velvet. He was also interested in the painter Botticelli, whom he introduced to friends and relatives, including his cousins Giovanni and Lorenzo, known as the 'Popolani', who promptly commissioned his two most famous works: the *Primavera* (*Spring*) and the *Nascita di Venere* (*Birth of Venus*). He gathered many artists around him: Ghirlandaio, Verrocchio, Luca della Robbia and other names that are highly appreciated today, nor could Leonardo da Vinci, whom Lorenzo de' Medici recommended to the Duke of Milan, be left out. Pollaiolo, Signorelli and Botticelli went to Rome, Verrocchio to Venice, and Leon Battista Alberti to Mantua. In short, the cradle of the Renaissance germinated and spread great geniuses throughout Italy, like seeds in the fertile countryside.

Leonardo drew the man inscribed in a circle and a square, also known as the 'Vitruvian Man', which illustrates trust in reason and, therefore, the exaltation of the secular values of earthly life typical of Human-

ism. In essence, the human body becomes the measure of painting; for Leonardo, it is an instrument of knowledge based on analytical observation of all things natural. An example of a different, more rational way of observing reality and explaining the phenomena of nature. Lorenzo actually created a favourable climate for the arts: many of his friends built palaces and decorated chapels.

Some works, particularly portraits, were commissioned for the lords' new residences, such as the so-called *Mona Lisa,* possibly the wife of Francesco del Giocondo. This was also the work of Leonardo who lived next door to them, which he painted during one of his stays in Florence, perhaps in 1503. Vasari had seen it[11] and tells us about it. Leonardo then took it away with him, continuing to work on it, and it remained in France, probably bought or inherited by King Francis I, his patron. It's now in Versailles, in the palace of my cousin Louis XIV.

Lorenzo's brother Giuliano fell in love with the beautiful Simonetta Cattaneo and the Magnificent himself also admired her. The loveliness of this woman, married to Marco Vespucci, became renowned throughout Florence.

– Botticelli was so enraptured that he portrayed her in *Primavera* with her long blonde ringlets and her robes draped over her voluptuous curves, surrounded by a sea of flowers of all species, colours and shapes. And you know how much I love flowers, Maria! A wonderful painting representing love in its two forms: physical and spiritual. Spring, or rather the youthfulness yearned after by Lorenzo in his verses.

– "Youth, that nevertheless slips away…"

– Well done, Maria! And in fact Simonetta, after having been portrayed on the banner of the 1475 joust held to celebrate the alliance with Venice and Milan, in which Giuliano triumphed, died just a few months later, demonstrating how fleeting life is and how we should be happy because "there is no certainty of tomorrow".

– What a sad story, Princess. Giuliano loved her, the whole city adored her, and she died during a time of the greatest happiness.

– "I sang, and now I weep, and I take no less / delight in weeping than I took in singing" recites the great Petrarch,[12] who knew how to tell of love like no other and has been imitated by many. So many sighs, alas! But let's return to Simonetta. Her relatives kept her coffin open at her funeral so that the Florentines could gaze for one last time on the beauty of her face, transfigured in the languor of death, but not yet corrupted. Poliziano dedicated his *Stanze per la giostra* to her, when her spirit was no longer there, unaware that other deaths would soon follow: among them, that of Giuliano three years later, in April, due to the blind violence of the men who hated my family. But let's think now of the beauty of Simonetta celebrated by Sandro Botticelli, who overcame death and corruption through his brilliant work.

– Yes, I saw the painting at the villa in Castello, next to the *Birth of Venus*, and I was enraptured. It's simply marvellous, that's all I can say. It must remain here Princess. You can't allow it to be taken away from Florence.

Love therefore guided the life of Lorenzo the Magnificent, "marvellously wrapped up in venereal things"[13] to cite Machiavelli, and he was probably also the author of love poems, or perhaps it was his faun-like profile that contributed to his fame as a great lover. The lord of Florence would certainly not have lacked opportunities to fall in love, but his real interests undoubtedly lay in politics and philosophy. Three important women left their mark on Lorenzo de' Medici's life: his mother Lucrezia Tornabuoni, a highly cultured and refined woman; Lucrezia Donati, his lifelong lover; and Clarice Orsini, his Roman wife, from an ancient noble family, who married him at the age of nineteen to cement an alliance with the pope, to whom the Orsini family was very close. The choice was made by Lorenzo's mother, who travelled to Rome in person and described her as follows in her letters: "of the right size and with a fair complexion, she has thick hair that tends to red … and her neck is slender and gentle … Her hands are long and slim", regretting that she could not see her chest as Roman women wore very high-cut gowns, unlike Florentine women.

The agreed dowry was 6,000 florins, a very high sum for the time, but he was a Medici and, after all, his grandfather had been the richest man in Europe. The wedding was celebrated with great pomp on 4 June 1469. Early in the morning, after sleeping at the home of the noble Alessandri family, Clarice mounted a white horse, a gift from the king of Naples, and was escorted to the palace on Via Larga. A wooden platform for dancing had been set up nearby, and between courses there was music and dancing, while someone recited Lorenzo's carnival poems. It was a sumptuous banquet, the likes of which had never been seen in Florence: it lasted three days, with sophisticated and surprisingly decorated dishes being served. It could not have been any other way at the wedding of the man who would be remembered as the Magnificent. Even the people got involved with admiration, collecting great quantities of gifts: calves, hens, wine and so many other things that it was impossible to know where to put it all. His father Piero, who was sick, followed the celebrations from his bed. He died six months later.

Despite the magnificence of that ceremony, his enemies lost no opportunity to point out that Lorenzo's heart was devoted entirely to Lucrezia, meaning not his mother, but Lucrezia Donati, who was married to Niccolò Ardinghelli. The woman, whom he had met when they were both sixteen, was the one to whom Lorenzo had dedicated the joust of horses and knights dressed in precious fabrics. He succeeded in beating everyone else on that occasion, receiving the laurel from the beautiful Lucrezia, whose colour he was wearing, as blue as the sky. All this happened four months after his marriage to Clarice.

Was it platonic love, literary love or sensual love? Who can tell and what does it matter, now that so much time has passed and all the flowers have withered, the beautiful fabrics torn and faded, and the two now turned to dust in their graves. "So many subtle beauties are gathered / in the gentle face of my woman",[14] he sang in a sonnet inspired by her, alluding perhaps to the themes of Petrarch's poetry.

– Princess, was Lorenzo really so well loved? Was he 'magnificent' in every sense?

– Loved, but not by everyone and also hated by many. Power has its splendours and joys, its pomp and grandeur, but it also conceals traps and poisons. What has gone down in history as the Pazzi conspiracy took place in 1478.

– Terrible! It is still spoken of as a work of the devil.

– The devil may have helped them in this, but the Christians decided. So, Maria, Lorenzo was truly 'magnificent' for being a shrewd and intelligent man, and yet he was not for everyone, as I told you… and nothing could prevent hatred from igniting the spirits of other families. The long-simmering resentment soon led to the plotting of a conspiracy in which the pope himself, Sixtus IV, was involved.

– The pope himself? No, it cannot be, I can't believe that Christ's representative on earth could do such a thing! As regards the rest, alas, I know how it went, in the cathedral, during mass… a bloodbath!

– The pope wanted to expand his possessions and saw Lorenzo as an obstacle. The annexation of Volterra by Florence, in 1472, led to the acquisition of the alum mines, a fixative used for dyeing cloth and in paints. However, this proved fatal because it upset the Salviati and Pazzi families, traditional enemies and business rivals. Indeed, they allied themselves with the pope, who commissioned loans from their banks instead of from the Medici bank, to the great detriment of our family. The Republic of Siena and the King of Naples also lent their support.

The conspiracy was concocted with great skill and considerable deployment of means: an army of mercenaries ready to intervene. But the devil, as we have already seen, helps to make the pots but not the lids. After a failed attempt, due to the fact that Giuliano had not turned up at either of the two celebrations in honour of the pope's nephew, Raffaello Riario, a decision was made to stage it on the first Sunday of ordinary time, before Ascension Day, in the cathedral, because once again the Medici had not even attended the banquet planned for that day in the palace on Via Larga. Not everyone agreed: killing in church during mass was indeed a sacrilege and perhaps, dear Maria, it was providence that intervened. At the moment of the elevation – or perhaps during com-

IV. THE 15TH CENTURY. RENAISSANCE

munion or dismissal – at any rate at the appointed signal, the conspirators unleashed their violence. A certain Bernardo Bandini Baroncelli was the first to attack Giuliano, striking him several times in the back, then ran towards Lorenzo, while Francesco de' Pazzi finished stabbing his body repeatedly. Lorenzo, accompanied by his friend Poliziano, was slashed in the neck by two priests, da Bagnone and Maffei, who were inexpert killers. Shortly afterwards he managed to enter the sacristy, where he barricaded himself behind the heavy doors. Archbishop Salviati, meanwhile, headed towards Piazza della Signoria with his trusted aides and around thirty armed men. They entered the palace but were disorganized and lost. Salviati met with the Gonfalonier of Justice, Cesare Petrucci who, unsuspecting, called the guards and armed himself together with the priors. The plan was for Jacopo de' Pazzi to go through the streets shouting "People and freedom!" and to garrison the palace from the outside with a hundred or so armed men in his retinue. This did not happen. Instead, a lynch mob was unleashed against the conspirators who were captured and hanged, according to the orders of the *Otto di Guardia e Balia*, from the window above the palace gate or from the windows in the Loggia dei Lanzi. Others were thrown down while still alive. "Balls! Balls!" our people shouted. It was 26 April 1478. No one would forget those days of blind violence, but Lorenzo's power was strengthened. The people loved him.

– Of course, Princess. How much violence there has been in the history of Florence, how many horrors in the name of love and freedom! Was this really a happy moment in the city's past, a moment of great inspiration?

– You're right, but men, whatever their rank, were unable to do otherwise. Women were cruel too, but perhaps, being more compassionate, they sometimes mitigated their ferocity. Lorenzo's mother, Simonetta Tornabuoni, tried her best, despite her grief at Giuliano's death, but failed. More massacres followed – the people in their fury even tore the corpses to pieces and raged against the two priests who were still alive. The Pazzi family were all arrested or exiled, and their property was confiscated. Their names were erased from official documents and all the

~ 73 ~

family coats of arms were destroyed. Lorenzo did nothing to appease the people's fury: he was avenged without blood on his hands.

– Oh, here we are, Princess, on Via dei Servi di Maria. We're heading to the church of the Annunziata, where all the wax figures hang in the atrium, isn't that right?

– Yes, Maria, do you remember? We've been there before, but perhaps we never talked about these buildings. In all honesty we only talked about frivolous things, like the clothes I would wear or what was going to be for lunch the next day. Now that I think back on it, I regret having wasted so much precious time on vain things and futile ornaments. It's so easy to be wise in hindsight.

– Princess, but youth ought to be cheerful and carefree. As your ancestor teaches us, one must make the most of the joys so as not to have regrets.

– You're right, but there's also a lot of melancholy in those verses. Of course with you I can afford to be myself, I don't have to play the part of the Electress, the haughty woman who receives everyone under a black canopy, only says a few words and walks away disdainfully. The vestal of a ruined temple. But all this philosophizing is useless. I'm a practical woman, as you know.

So, this street that we're walking down was home to the workshops of the wax modellers or '*fallimmagini*' who made the objects that were subsequently displayed in the church in thanks for grace received or for a prayer to be answered. Look, there are still a few here. Smoke comes out of the door, and the craftsman stops still before going back to forge the images inside a large wax-scented cauldron. Sadly, this is no longer the Florence it once was and the workshops are now few and far between.

The carriage resumes its journey towards the church, which stands out in white at the end of the road. To the right and left stand two buildings with white and grey arcades. We get out and enter the church.

– Oh! What a wonderful painting. It's the effigy of the most pure mother of God, the one the angels painted.

– Those before us, on the other hand, are a multitude of small, large,

new or old and worn figures, all hanging on the walls as memorials. Apparently, more than 6,000 people were healed: one was shot with an arrow, another was blind, that wax hand means he was a cripple, and the cherubs represent prayers to help women conceive and become mothers.

Yet the most beautiful building in the square is the Spedale degli Innocenti, built by the *Arte della Seta*. It was here that foundlings were reared and educated, as recalled by the ceramic decoration by Andrea della Robbia, which features children in swaddling clothes against a blue background. The portico is the work of Filippo Brunelleschi, who was inspired by Roman buildings but added a touch of Florentine elegance in the lightness of the columns on the ground floor. The arches are wide because the artist wanted the cross vaults to be visible from the square, and the entire portico is raised above street level by a broad flight of steps. The square was designed taking into account the perspective formed by the white of the stucco and the grey of the *pietra serena*, which create harmonious lines, all according to a fixed and pre-established measurement based on mathematical principles. In the elegance of Renaissance buildings, the eye only perceives a sense of harmony and balance: this is the lesson taught by the ancients. Humanism, as freedom of thought and expression, envisages a return to the study of classical art and a spirit that breaks free from the rigid morality of the Middle Ages.

Brunelleschi, Masaccio, Alberti and Michelangelo looked to the lesson of the immense classical past with the ambition of founding another great art. The invention of perspective is attributed to the excellent Brunelleschi, assisted by the mathematician Paolo dal Pozzo Toscanelli.

The great architect discovered the principles of linear perspective using a board with a hole in the centre and a mirror. And he realized that there must be a single vanishing point where all the receding lines converge.

– The dynamic Medici court represented the height of European culture at the time. Great artists were attracted to Florence and travelled to Rome to experience the proportions and expressiveness of the city's art for themselves. But Florence was a hotbed of genius: the fulcrum of

the new art. The perspective through which to look at the great classical past.

– Princess, from here, from this square, you can also see the great dome that links the Annunziata with the Duomo like a thunderbolt, following Via dei Servi.

– Maria, I see you understand the meaning of perspective! But come here. Can you see that little window with the bars under the portico, above the steps?

– Yes, Princess. That's where you put babies and ring a bell to alert the attendants that there's a new arrival. The baby can't be too big, otherwise it won't fit through the gap in the window.

– You're well informed, after all, this institution is very well known both in Florence and in Tuscany. Siena has the great Ospedale della Scala where the 'gettatelli' are taken in, and since Siena was annexed to the Grand Duchy, the Scala also came under the direction of the Innocenti. The children were nursed, brought up and educated, with the boys learning a trade, but also the first rudiments of writing and reading, and how to count. These are important skills for a craftsman.

– Not for the girls though, Princess. They learn to sew and embroider, and are given a dowry so that they can marry.

– Maria, you really surprise me.

– I thought you knew about my history. You've never asked about me and my past.

– That's true, you were chosen by my secretary. You were very young and they told me you were from Mugello, and you were a God-fearing and very honest girl. I've always been pleased with you. Quiet and efficient, you guessed my every wish and you were invisible to me until now. It's only now that I realize I appreciated these qualities in you, but I didn't know you at all. The unusual intimacy that has been established between us is a gift from Our Lady, otherwise it would never have happened.

– Princess, this is the way of the world and I don't regret it. I've been your shadow, but quite happily I would say. I consider myself lucky, as otherwise I would have lived with a peasant who would have only mar-

ried me for my dowry and to have his children. He would probably have beaten me and humiliated me, and I would have spent my life working non-stop from dawn to dusk... I know the fate my companions have suffered and I can assure you that they have never spoken of love, such as you have described with regard to your ancestors.

– Well, Lorenzo's wife Clarice and other women from the House of Medici also had to obey. When Clarice was on her death bed, Lorenzo was at the Bagni di Lucca nursing gout. He didn't even attend her funeral. Records tell us of a funeral with no show and no pomp, despite the fact she had given him seven children.

– If you wish, I'll give you a brief account of myself, although I don't know much either.

– Tell me, Maria. I'll listen to you gladly. We're both old and we're keeping each other company. You know everything about me and I know nothing. I'm eager to get to know you.

– My mother, whom I never met, brought me here at dawn on 8 September, the day of our Lady's Nativity, which is why I was called Maria, Maria Vittoria (that means 'victory'). The second name was a good omen. I was fed by a wet nurse and then raised with love in accordance with God's law. The nun who took me from the pile said that I was wrapped in a celestial 'shawl' and had one half of a medal sewn on me. It's all written down and kept in the hospital archives. As a child, I always hoped my mother would come back for me, showing the other half-medal and mentioning the shawl, made of fine fabric, so I have been told. My fine features and blonde hair suggest that I was left by a noblewoman. No one came, and all the time I was there I heard of very few children returning to their family, and those who did were almost always boys. When I got older I helped the sisters with the chores and played with the little ones. That's when I learnt to read and write, and proved that I was bright and intelligent.

Having reached marriageable age, I was promised in marriage to a man from the Vicchio countryside. I saw him and burst into tears. He was old and crippled and I didn't desire him in any way whatsoever. So I begged the mother superior. I said I couldn't go through with it because

in my heart I'd promised myself to Jesus. She, who loved me, spoke to the rector and, after much insistence and prayers to Our Lady, I was let off. I'm stubborn, I know, but I also had good fortune on my side. Had it not been for the Mother Superior, they would have forced me without a doubt. They sent me to a convent in Mugello, in Santa Caterina di Borgo San Lorenzo, near your villa in Cafaggiolo.

I liked being there. I felt protected, I was serene, I prayed and embroidered, and I also had time to read. In the library, in addition to the lives of the saints, I also found the *Divine Comedy* and *The Lives* by Giorgio Vasari. I was interested in learning about these great artists. I hadn't yet taken my vows when one day, at an interview, a lady from the villa saw me and, finding me pretty and sharp, inquired of the mother superior and recommended me to the superintendent, because His Lordship was looking for a maid for Cafaggiolo. I accepted thinking it was a miracle come true. The heavenly silk cloth in which I was swaddled had been a good omen and I wanted to see something of a mother in you. Please forgive my boldness and effrontery, I should not have told you that. In any case, it was indeed a 'victory'. From then on I stayed with you in Saxony.

– Poor Maria, I'm not your mother, nor could I be, but you're the person closest to me and I'm grateful to you. I knew nothing and I regret it, but I believe that your prayers and concern for my person have helped you, and while you have not found the woman who gave birth to you, you have at least found a home to welcome you. Our Lady whose name you bear brought us together – the heavenly shawl is a sign. One day I will take you to the Spedale degli Innocenti so that you can ask for more information about yourself and perhaps find…

– Thank you, but at this point in my life, I prefer not to. I longed for it for so many years, but it didn't happen. I don't want to continue chasing illusions that would leave me unfulfilled and sad. Maybe that woman had her reasons, maybe she was forced, maybe she died giving birth to me. Now I'm finally free of regrets. And then, as the old people say, "In a hundred years and in a hundred months water returns to her countries" and so we have met.

We return to the palace in silence. The carriage arrives in Piazza Duomo and continues to Palazzo Pitti. It has been a busy day and Maria reflects alone. I prefer to leave her wrapped up in her thoughts. It can't have been easy for her to confess her origins and tell me about them and the pain of being abandoned. How many children suffered the same fate! Most died in their first year when they were entrusted to wet nurses in the countryside: needy women whose children had died or who had plenty of milk for two or three children. And just think that in our family they would have paid through the nose for an heir that never came, a child to carry on the Medici name. I too prayed to the Most Holy Virgin Annunciate for a son. That grace was not granted to me.

The Spedale degli Innocenti, in all its magnificence, can be considered the emblem of a civilization that, given its great commitment to public works, took charge of the plight of abandoned children in an effective and rational manner. It was indeed a time of extreme violence, as evidenced by the exiles, bloodshed and vendettas, but it was also a time of Christian concern for the poor, the unfortunate and especially children, given the very high number of shelters, hospitals and places of care, such as the Misericordia in Piazza Duomo, the Bigallo, and the San Martino dei Buonomini oratory. The latter was built at the behest of bishop Antonino Pierozzi. It was a place where members of wealthy families would go in secret after falling into disgrace, often due to family feuds or illness.

– Maria, are you familiar with the Florentine expression '*essere al lumicino*'?

– Of course, Princess. When they ran out of resources to help those who came to them, the Buonomini of the oratory of San Martino would put a *lumino* (lamp) outside the door to signal the need for offerings, hence the expression.

– Exactly, and after the Pazzi conspiracy, many who were not killed but spared by Lorenzo, found themselves '*al lumicino*'.

In order to safeguard his position, Lorenzo the Magnificent created a handpicked council of seventy members, to whom he entrusted power, particularly the election of the main government offices. In 1490 he concentrated everything in a council of seventeen, of which he himself was a member, the *de facto* lord of Florence, the first among the citizens in word only. However, it was he who spoke with the princes and the king of France. He was the arbiter of a divided country, Italy, which was about to become prey to foreigners. Nevertheless, it resisted for as long as he was there. In 1489 he obtained the cardinalate for Giovanni, his thirteen-year-old son, who was ready to found a princely dynasty. But everything was inextricably linked to his strong personality and name.

Absorbed by politics and the arts, he had neglected the family business. The foreign branches were on the verge of bankruptcy and interest was no longer being paid. Lorenzo was reduced to borrowing from friends. He sold the villa in Cafaggiolo and the palace in Milan. He used the funds of the Monte delle Doti and speculated on taxes to such an extent that Machiavelli is reputed to have said "in his other private affairs he was as unhappy as in trade".

– Funereal omens, Maria, accompanied the last days of his life in 1492. The lion of the Signoria had been mauled by other beasts, lightning had struck the lantern on the dome of the Duomo destroying about half of it, a possessed woman screamed in the church and many swore they had seen howling ghosts behind the villa in Careggi. The city was terrified of what would happen next. It sensed a catastrophe.

– And it had good reason, Princess.

– Indeed… when Lorenzo passed away, at the age of just forty-three, the balance he had so painstakingly constructed was shattered, and the succession of his son Piero 'the Unfortunate' proved to be a catastrophe, culminating in the descent of Charles VIII into Italy. But the ruin of the Medici companies had already led to bankruptcy and there were no more florins to spend on a war. Piero allied himself with the king and is said to have stooped to kissing Charles' slippers, betraying a need for freedom that had never been tamed in the Florentines' souls. On 9 November

IV. THE 15TH CENTURY. RENAISSANCE

1494, Piero was banished and the palace on Via Larga was sacked by the people, instigated by a Dominican preacher who was to be much talked about: Fra' Girolamo Savonarola. The immense treasures and works of art, carefully collected by my ancestors, were dispersed or destroyed in a flash. There was complete havoc! Piero had been nicknamed the 'Unfortunate' since childhood, but he was really rather clumsy and ignorant, that 'insane big-headed Piero', as his father referred to him. The King of Naples demonstrated great foresight when he said that Lorenzo had lived long enough to achieve immortality, but not enough to ensure the salvation of Italy.

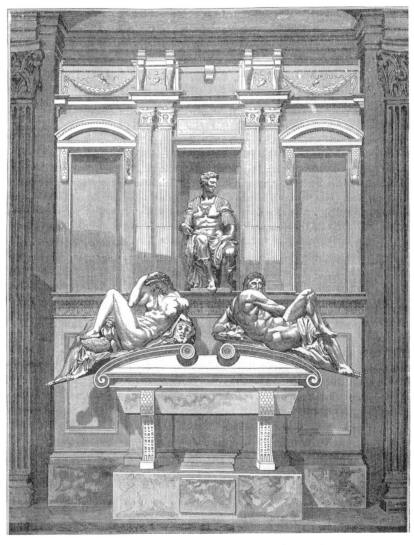

Tomb of Lorenzo de' Medici, Duke of Urbino, in the New Sacristy of the Basilica of San Lorenzo in Florence.

V. The 16th Century

The Grand Duchy

A new day dawns for us and for Florence.

– Dear Maria, you appear calmer today, and you're wearing an immaculate piece of lace on your dress which gives you a graceful look. Well done! We had an intense day yesterday, especially in your case when you found yourself outside the Spedale degli Innocenti once more. Today I'd like to take you around again and show you some more treasures. I'd like to steer clear of the subjects of violence and abuse if possible, but I'm afraid that won't be easy.

– As you please, Princess. I'll be happy to listen to you in any case.

– The discovery of a new continent, named after another Florentine, Amerigo Vespucci, shifted the focus of trade towards the Atlantic Ocean. The King of France's ambitions for Italy and the weakness of the Signorie were a fact. Florence was heading towards economic and political decline: it was torn apart by infighting, threatened by commercial competition from the Portuguese and Spanish merchant fleets, and deprived of many of its artists, who had been lured to Rome by Pope Leo X.

– And what about that friar, Girolamo Savonarola. Can you tell me anything about him?

– Of course!

~ 85 ~

After the expulsion of Piero, who died in exile in 1503, the Florentines reorganized themselves into a Republic. The people, animated by the sermons of Girolamo Savonarola, seemed to have regained their strength and reformed the government. The friar, originally from Ferrara, studied theology and entered the Dominican Order, later arriving in Florence, in the convent of San Marco, at a critical moment for the city. As an unarmed prophet he inflamed tempers, hurling darts at usurers through his extremely popular sermons. The city was divided between the 'angry', the supporters of my family, and the 'whiners', the followers of Savonarola, who were enraged by the corruption of the Church, but above all by luxury and the vanity of art. The Dominican ordered fine clothes and even some painted panels to be burnt in Piazza della Signoria to the general applause of his followers on the one hand, and to the horror of cultured and enlightened men on the other. The intransigence of the friar, who raged against the Papal State and the debauchery of the city's customs on a daily basis, was not tolerated for long by the Florentines, so much so that Savonarola himself soon ended up being burnt at the stake in that very square, on 23 May 1498. And it was also there, years later, that Michelangelo's *David was* placed, commissioned from him by the Arte della Lana and the cathedral workers in 1501. Three years later, a special committee made up of the city's most illustrious artists, such as Andrea della Robbia, Botticelli, Perugino, Leonardo, Filippino Lippi and Giuliano da Sangallo, decided where to put it. They chose a place that would correspond with the image that the proud but fragile republican government wanted to give of itself.

– Michelangelo's *David* is undoubtedly the most beautiful statue in the world.

– Even more beautiful than the works of the Greeks?

– Definitely. It draws upon classical inspiration, but there's a different sense of proportion here. We could describe it as perspective from below, with very large hands and head to emphasize the action the hero is about to perform with his sling. It was made from an enormous piece of marble that had already been roughly hewn and which the young Mi-

chelangelo managed to sculpt despite it having a material defect. Nobody thought he could do it. It was a feat for giants, and Michelangelo proved himself to be one.

– This isn't a youth like Donatello's *David*, Princess. This is a virile and strong man, shown naked, in the manner of the ancient athletes.

– Yes, he represents the Renaissance ideal of male beauty, but above all he is the emblem of the Republic and the symbol of the civic virtues he embodied.

However, the Republic didn't last long and, thanks to the support of the pope and Spain, the Medici were welcomed back into the city by the tired and frightened Florentines in 1512. Cardinal Giovanni, son of Lorenzo the Magnificent, appointed his brother Giuliano as regent. Then, having become pope under the name of Leo X, he acclaimed his nephew Lorenzo, son of Piero 'the Unfortunate'. In the meantime, Lorenzo's sister, Clarice, had married Filippo Strozzi, a very rich man and former enemy of the family, who was now an important ally for their return to Florence. After a long battle, Lorenzo also obtained the title of Duke of Urbino, but was not up to the task. In 1521 Pope Leo X died and the Magnificent's last son disappeared with him. All that remained of his legitimate branch was the little Catherine, Lorenzo the Duke of Urbino's only heir, who was destined to become Queen of France. Meanwhile, Cardinal Giulio, the natural son of Giuliano who was killed during the Pazzi conspiracy, had uncovered a plot within the Accademia degli Orti Oricellari: two young men were condemned to death and Niccolò Machiavelli, suspected of plotting, was tortured and then acquitted. In 1523, the cardinal was elected pope with the name of Clement VII. Having to leave Florence, he chose two illegitimate children in his stead, Ippolito and Alessandro, both of whom had only just turned twelve. They were placed under the guardianship of Cardinal Passerini, who in fact ruled over the city alone, with an exaggerated and tyrannical government, which constantly oppressed people. In 1527, when the Landsknechts violated the Holy City in the notorious sack of Rome, an orgy of bloodshed spread across the land: fire, depredations, destruction and ferocious

violence against women under the eyes of their relatives. The shocked Florentines took advantage of this to drive the Medici out again.

– Again, Princess?

– Yes, Maria, it was the third ban, after Cosimo's in 1433 and Piero's in 1494, and next there will be the fourth and final one, at my death. In my case it will not be ordered by the Florentines, or the Republic, but by the great European powers, as Tuscany is just a small pawn in a game bigger than herself.

– Princess… maybe something can still be done, maybe they will reconsider. After all, the Medici have ruled for almost three centuries and have done so much for Florence!

– No, Maria, that's not possible. As our own Niccolò Machiavelli used to say, we were unable to put remedies in place when the time was right, and fortune has now deserted us.[1] Everyone yields, defenceless, to the impetus of fate as to a river in flood, although they could have built levees and canals during quiet times to prevent the fury of the water from destroying everything. So our history repeats itself and we have learned nothing from the past, as Machiavelli, spectator of those tormented days of the Republic and the return of the Medici, wanted to teach us.

He truly hoped to obtain a new post, albeit in vain, after having held the position of Secretary of the Second Chancellery of the Florentine Republic. He dedicated *The Prince* to Lorenzo de' Medici himself, not Lorenzo the Magnificent, but the Duke of Urbino, son of Piero. No one embraced his appeal and he grappled with assignments of little value, even though he was aware of his own virtues or, rather, his genius. When he was in exile in San Casciano, he wrote to his friend Vettori, "I fool myself all day long playing the game of *cricca, trich-trach* … When evening comes, I return home, and go into my study … and I put on my royal and courtly robes; and dressed up, I go into the ancient courts of the ancient men",[2] alluding to the study of the classics from which he learnt as much as from his extensive experience in politics. He was not understood by his contemporaries; he died in 1527, unable to imagine that posterity would consider him a genius.

– What an unusual work, Princess… I didn't know about it.

– *The Prince*, written in 1513 and inspired by Cesare Borgia, marked a turning point in political thought, introducing the study of politics with a scientific method. Machiavelli's greatness lies in having theorized that those who want to know the rules of this science must draw their inspiration from reality: Machiavelli is convinced that human nature remains fixed in time and tangible history is nothing but an infinite and successive application of those constants.

Anyone who wants to get involved in politics in the belief they will be dealing with people who are more good than bad, anyone who intends to act in a world dominated by violence without being willing to use violence in the name of a higher ideal if necessary, will not make a very good prince. Machiavelli argues that the prince's morality must depend on and respond only to the preservation of the state and not to personal principles, whether religious or secular. He highlights the fact that those who act in politics without following these techniques are doomed to failure.

Dear Maria, Italy found no prince willing to unify it – that was what the secretary 'aimed' to achieve through his work, but people didn't understand. It was a theory ahead of its time, which is not ripe even now, and who knows if this Italy of ours will ever be unified… "Ah, abject Italy, you inn of sorrows",[3] as Sordello da Goito says in Dante's *Purgatory*.

– What a sad fate!

The day after the sack of Rome, Florence rose up again in the name of freedom and restored the Republic: the gonfalonier Niccolò Capponi proclaimed Jesus Christ king of Florence, following the echo of Savonarola's sermons. However, the Republic was short-lived. It withstood a ten-month siege by Charles V's imperialists who, in agreement with Pope Clement VII, wanted the return of the Medici at any cost. The attack was harsh and the city did its best to resist. Even Michelangelo got involved, designing the defensive works around the hill of San Miniato, and they tried to give the impression that everything was under control, continuing to celebrate Carnival and playing football in costume in Piazza Santa Croce. However, in reality, hunger and disease ruled inside

the walls. Our citizens surrendered after a long battle, which also cost the enemy a few defeats, and which was conducted under the leadership of Francesco Ferrucci, who went down in history for the phrase "Coward! You kill a dead man" directed at Fabrizio Maramaldo as he was about to finish him off with his dagger even though he was already wounded. Thus ended the Florentine Republic.

On 12 August 1530, a parliament held in Piazza della Signoria agreed to the return of the Medici in the person of Alessandro, who was appointed head of the Republic, duly guided by Pope Clement VII. In 1532, the members of the Signoria gave him absolute power on the basis of an imperial decree: a tyrant who received the title of duke. It was over for the Commune, the Republic and ideals of liberty. The swan song was to be the killing by Lorenzino de' Medici – a member of the family who went down in history as 'Lorenzaccio' – of the duke who was immediately replaced by Cosimo, son of Giovanni dalle Bande Nere, another branch of the family descended from Lorenzo, brother of Cosimo the Elder.

The young Cosimo was to become a man of great virtue, albeit not those proclaimed by Machiavelli. Certainly the combative example set by his father and paternal grandmother Caterina Sforza, a great fighter in political life, helped him. It was a combination that could only yield great results. Indeed, Giovanni dalle Bande Nere was an illustrious captain of fortune who died prematurely from a war wound. As a child, his mother, a refugee in Florence, kept him hidden in the convent of Annalena, dressed in skirts like a little girl to protect him. He was then brought up in the Salviati household by Lucrezia dei Medici who, realizing his remarkable abilities, wanted him as husband for her daughter Maria Salviati. That union led to the birth of Cosimo.

He was a leader of great virtue and courage. In foreign policy, he strengthened the rule of Florence, annexing Siena that traditionally rebelled against any attempt at submission, and he knew how to juggle in the political games between France and Spain. Militarily, as the son of a mercenary captain, he came up with the idea of reorganizing the army, building fortresses and expanding the territory. And he obtained the title of the first Grand Duke of Tuscany in 1570.

V. THE 16TH CENTURY. THE GRAND DUCHY

– And this marked the start of the Grand Duchy, right?

– Yes, exactly.

– And what happened to the *David*?

– Dear Maria, Michelangelo's statue of *David*, an ode to the freedom of the Republic, survived the proclamation of the Grand Duchy, even though it suffered numerous acts of vandalism, including the shattering of an arm, during the Medici expulsion in 1527. Cosimo subsequently had it restored, although traces of the damage can still be seen.

– The Florentines had lost the freedom they so acclaimed, but they did not lose the marble symbol that will represent it in eternity.

– I don't know whether it will be in eternity, because nothing is eternal except hell, as Dante says. "Before me nothing but eternal things / Were made, and I endure eternally".[4] But here we are talking about beauty, about art. About change and transformation. This is what can be said about the Palazzo della Signoria, which we have before us, built by Arnolfo di Cambio and then transformed by Cosimo into a private residence, on the basis of a design by Vasari, who doubled its surface area.

– But, Princess, has the plume always been there? It looks a bit crooked to me!

– What plume? Ah, you mean Arnolfo's Tower! If you look at it, it is slightly off-centre to the right, because it was built on a pre-existing tower-house that belonged to the Foraboschi family, called 'della Vacca' ('of the cow'), because of the nickname the Florentines gave to the large bell that stood there.

– That's where they locked up Cosimo the Elder before exiling him, isn't it?

– Yes, in the Alberghetto, where poor Savonarola also stayed before his sentence was carried out in the square: he was hanged here and then burned. Besides, as Machiavelli says, unarmed prophets face "ruin":[5] meaning that anyone who does not have an army at their disposal is doomed to fail. In fact, many who were on his side went and hid when he was arrested and did not defend him.

– But he also said some good things, speaking out against the corruption of the Church, against excessive luxury, for the good of the poor…

– This is exactly why he was excommunicated and then executed. Just think that when Cosimo I arrived and was acclaimed in Florence, everyone seemed to have forgotten Fra Girolamo, and Machiavelli was also considered one of many. His books were included in the Church's index of prohibited books.

– Princess, everyone remembers Cosimo and the statue of him on horseback is also located here. It's impressive!

– Yes, well done! It's the statue by Giambologna, commissioned by Ferdinando I to celebrate him. And then on the other side are the Uffizi, the offices of thirteen important magistracies for the administration of the Medici State, built by Vasari in just six months while he was also working on the palace. The Grand Duchy needed premises suitable for a modern state. Vasari also had a gallery built connecting the palace – henceforth called the Palazzo Vecchio – with the grand dukes' new residence, Palazzo Pitti. In fact, the grand duchess, Eleonora di Toledo, daughter of the viceroy of Naples, had bought it and had it enlarged. She considered Palazzo Vecchio to be cramped and poorly lit, judging the Oltrarno area to be better for her children's ailing health. The Medici family could move through Vasari's gallery, a kind of elevated street, from Palazzo Vecchio to the Oltrarno, arrive at Boboli and from there reach Forte Belvedere without encountering any ill-intentioned or over-exuberant people. The grand dukes could even attend mass in Santa Felicita from a balcony protected by a gate. We too could have the opportunity to walk along the corridor, but I prefer to ride in a buggy with you, to be among people, albeit discreetly.

– Long gone are the days, Princess, when Cosimo the Elder and his nephew Lorenzo roamed the streets between two ranks of the crowd and shook people's hands, patting their children on the head…

– Don't forget the numerous attacks on their persons, Maria. What's more, the grand dukes feared that they would not be loved by the population, given the reversal from Republic to Grand Duchy.

– Princess, 'water and the people cannot be held back', but perhaps the people didn't really care, even though so many proclaimed them-

selves to be for the Republic. What they wanted was peace at last and a decent life, after all the deprivation and starvation during the siege.

– They wanted festivities too, Maria. The Florentines loved them. In order to ingratiate themselves with the people, in addition to the numerous celebrations such as that of San Giovanni, Cosimo instituted the Palio dei Cocchi. Now let's go to the place where it was held so I can show you one of the most beautiful facades in the city, that of the church of Santa Maria Novella.

The buggy takes us at a trot through the narrow streets behind the Duomo, with the little houses leaning against each other and the unhealthy air one breathes in these parts, where people neglect to clean up the rubbish. The inhabitants themselves have a dull air and a yellowish complexion that reveals malnutrition and disease. It's no longer the opulent Florence of the merchants, nor even the celebratory one of Cosimo. It's a town on the edge, where the last royal princesses didn't want to reside, despising its backwardness, without taking an interest in the treasures it holds.

– Here we are, Maria, in Piazza Santa Maria Novella. What you see is Leon Battista Alberti's facade, which was the backdrop for the Palio dei Cocchi. The decision to hold it in this square was dictated by the belief that in ancient Roman *Florentia* there was a hippodrome here where chariot races were held. It was decided that every year, on the eve of the patron saint celebrations, 23 June, a race would be held with four chariots, each pulled by four horses. They would each represent one of the city's quarters – Santa Croce, Santo Spirito, Santa Maria Novella and San Lorenzo – and would be identified by different colours. The Grand Duke waved a white kerchief, after which the carts raced three times around the course, which was bordered by two wooden obelisks, as in the Roman races. Next to the loggia, the grand ducal family watched from a stand set up for the occasion and all around the Florentines cheered for their colours. A jubilation of arms waving coloured cloths, shouting and crying, cheering and jumping for joy. I too participated from up there and I assure you it was a magnificent celebration. It's not been held late-

~ 93 ~

ly, but I hope it will be revived in the future… although I doubt that will happen when the barbarians arrive! And then there was the Palio dei Navicelli involving the boats in the Arno. In short, festivals represented the heart and soul of the Medici governments.

– Princess, I read that these tortoises under the obelisks represent the patience and industriousness of the Florentines. Is this true?

– Maria, that could certainly be one interpretation… I know for a fact that the tortoise topped by a sail is the symbol of Cosimo I, so the tortoises on the obelisks refer to him and to his motto *festìna lente*, which means 'make haste slowly'.

– Exactly, princess, just like these animals do. Always moving, but slowly.

– You see, Maria, symbols are important. Some are easy to identify, such as the fleur-de-lis, the Medici balls and the Marzocco, while others require esoteric knowledge that not everyone possesses. Indeed, I would say this knowledge only pertains to the initiated, as in the case of the designs on this facade. Leon Battista Alberti, who designed it, was a fine scholar and a great connoisseur of Roman art, like the humanists we have mentioned. He used white and green marble, harmonizing it with the lower part, which was left almost intact in its Gothic layout, adding only the classical-style portal framed by pillar-columns. The upper part is decorated with panels, inspired by ancient Greek art, linked by geometric relationships with the rest of the elements on the facade. Look at the large oculus that seems to be watching us: almost as if to indicate the flaming solar disc inside the tympanum with the face of the Christ Child, emblem of the Santa Maria Novella district. On either side we see the volutes, framing two other discs. It is all extremely rigorous, but in the context of a more open and less severe facade than Brunelleschi's monuments.

– But what are those two elements on the facade? I don't even know what they are called.

– They're two instruments, added later by an astronomer friar: a kind of sundial and an armillary sphere. While Santa Croce was, and is, an ancient centre of Franciscan culture and Santo Spirito was home to the

Augustinian Order, Santa Maria Novella was commissioned by the Dominicans, but the facade was financed by the wealthy cloth merchant, Giovanni Rucellai.

– Princess, is this where the women of the *Decameron* met before leaving for the villa at Settignano?

– That's right. We're going inside too.

I suspect that the guards at my side always keep away those who try to approach. A halo of emptiness persists around the two of us, like an air bubble separating us from the others, although I wouldn't mind having a chat with simple people. But I know it's not appropriate, at least not at the moment.

The interior is Gothic, with ascending lines that seem to lift us upwards, in a very simple fashion. A sense of spirituality emanates from it all, which I often overlook when observing artworks. Beauty distracts from prayer but it is certainly a noble way to glorify God. There is a fresco of the Trinity by Masaccio. It's one of the masterpieces of the Renaissance and the result of extensive study by the painter. Masaccio was the first to apply perspective to painting, just as Brunelleschi applied it to architecture. Not only that, but it's also a study of anatomy if one observes the body of Christ. Masaccio also painted the very beautiful cycle of frescoes in the Brancacci Chapel at Santa Maria del Carmine, with such vivid scenes of Florentine life that one feels as if one could step inside.

– Behind the tabernacle of the high altar I will show you not only some very fascinating frescoes by Domenico Ghirlandaio, but some details that will tickle your feminine vanity, even if you are so austere in your dress.

Maria, solicitous, looks at me curiously and nods with a big smile. Her presence has become familiar and necessary to me in order to understand things. She's like a mirror on whose surface I observe, am observed and reflected.

– What sumptuous clothes these ladies are wearing, but aren't they too fine for a poor woman like Our Lady was? Maria exclaims.

– Of course! However, the patron, who was Giovanni Tornabuoni, was mainly interested in displaying his family's wealth, and Ghirlandaio liked portraying furnishings and, above all, as Vasari tells us, people. When he was in a goldsmith's workshop, he portrayed the peasants and the people passing by, and they looked very much alike.[6]

– This young girl in front of us, in the scene of the *Nativity of the Virgin,* is very pretty and wears a wonderful dress with white designs against a dark background and sleeves!

– Yes, the sleeves were fastened with tiny buttons and then, if you look closely, there are gold and silver threads in the fabric. These were the world-famous brocades made here in Florence in the art workshops that worked silk and which, in the 15th century, became more prosperous than the wool workshops. The *battiloro* (gold beaters) would prepare the threads used to embellish the fabrics. Nevertheless, in this fresco, the women's hairstyles are quite simple. But just observe how clear the water is falling from the jug, and the perspective view of the staircase. In short, it's a rich but also an intimate scene among women. The first one, shown in profile – the one whose dress you admire – is Lodovica Tornabuoni, the daughter of the patron, who looks very much the part, composed and dignified.

– I would love to see other clothes like these…

– A similar but much richer gown is worn by Cosimo's wife, Eleonora di Toledo, in Bronzino's portrait of her with her son Giovanni. The fabric features a riot of decoration, with black and gold stylized floral weavings on a light background, a mesh of gold threads and pearls on the neckline, and two necklaces of equally magnificent giant pearls around her neck and on her chest. You know I have a weakness for jewellery but I have never owned it. Who knows what happened to it? It must surely have been lost in the looting! The dress is the one she was buried in. The elegant and cold Eleonora was a suitable wife for Cosimo. It was a successful marriage, until the tragedy that took away two children in the space of a few days due to malarial fevers contracted in Maremma. Shortly afterwards, they were followed by Eleonora herself.

– The Spanish chapel is this large frescoed chapter house, Princess?

– Yes, and it was used to hold services for Don Pedro of Toledo and his small court when they came to Florence for his daughter's wedding with Cosimo. He had chosen well, a wife worthy of a duke, but also a good overseer, who added to the family fortune by purchasing houses and land.

The intelligent and tenacious Cosimo was an excellent administrator of the state, although as a young man he gave the impression that he could be easily outmanoeuvred. In supporting his appointment, Guicciardini was under the illusion that 'with a pot of 12,000 florins a year, that young man would give himself a good time and leave him and a few other qualified men the grateful trouble of governing, helping themselves to and exploiting the state'. He was a tall, robust and elegant man, with large, bright and intense eyes, just as he appears in the portrait in the Salone dei Cinquecento, in the centre of the ceiling, crowned by the goddess Flora, with the city's coats of arms and the insignia of the Florentine Arts around him, as portrayed by Vasari. He always adopted a reserved and distant, 'duke-like' attitude, but every now and then, at the table with his family, he would let himself go... He improved agriculture thanks to land reclamation works in unhealthy areas; he endeavoured to revive commerce by developing the port of Livorno, but by then the rich Florentines invested very little in mercantile activities, preferring to focus on the land. He exploited natural resources such as the silver mines in Pietrasanta, marble in Carrara, and iron on the island of Elba.

At the time, artistic and intellectual life was still quite exuberant due to the presence of some wonderful artists, including the architect Ammannati, the sculptor Benvenuto Cellini and the painters Pontormo, Bronzino and Vasari. However, the great Michelangelo was working in Rome and did not want to return, even though he was called back by Cosimo: his republican spirit prevented him from doing so or perhaps, as his enemies claim, the pope could pay him more. The Grand Duke favoured the establishment of numerous academies and financed theatrical performances with ingenious stage sets.

– So was Rome more important than Florence?

– Rome was the centre of culture and Florence was on its way to becoming a marginal city in a world divided between great and powerful states. All this was despite the efforts of Cosimo, who was nevertheless an excellent prince and retired at the age of forty-five, leaving his son Francesco ruling a state in good health.

– And what can you tell me about Francesco?

– Francesco didn't have his father's talents and seemed more interested in studying alchemy and experimenting alembics in the Studiolo that had been set up in the Palazzo Vecchio. Here he lived with his wife Joanna of Austria, daughter of Emperor Ferdinand I of Habsburg, until the death of his father. He died in mysterious circumstances, possibly poisoned, together with the woman he was madly in love with, Bianca Cappello. Maria, you must have heard about Francesco I's love for the Venetian beauty?

– Yes, Princess, a mad love that drove them both to a violent death, "Oh our life that is so beautiful to see, how easily it loses in one morning what has been acquired with great difficulty over many years!",[7] as Petrarch writes in the *Canzoniere*.

– You know those beautiful verses! However, there's no evidence that they were poisoned. What's certain is that they died in the villa at Poggio a Caiano and that his brother, Cardinal Ferdinando, the future Grand Duke, was present. It seems more likely that they were struck down by a sudden attack of pernicious malaria, the same malaria that had taken Cosimo's two sons!

– I know their love story. I've always been fascinated by it, Princess, and in my opinion Bianca, a Venetian noblewoman who became Francesco's second wife against everyone's advice, was an exceptional woman, as well as being extremely beautiful, with a cheerful manner and graceful demeanour. Apparently she had stunning coppery hair and an alluring Venetian accent that charmed everyone, but why do we have so few portraits of her?

– When the pair of them died just one day apart in October 1587, Ferdinando ordered that all memory of Bianca be destroyed, erased her name and wanted her buried in an unknown place.

— Whatever the case, Princess, he could not prevent the love story from winning out over time and becoming immortal, thanks to those who wrote about her and her love.

— Two other unhappy women were sacrificed by their husbands during that period. Francesco's sister, Isabella, and his sister-in-law, Eleonora di Toledo, namesake of Cosimo I's late wife. These two murders, which took place within a few days of each other, left a dark aura around Francesco, who was never loved by the people, not least because of the ferocity with which he took revenge on certain conspirators at the beginning of his reign.

It's important to remember that during his rule, the Accademia della Crusca was founded on the initiative of a number of important scholars to promote the pure language.

Ferdinando, who had become Grand Duke due to Francesco's death without an heir (his only son with Joanna died at the age of five), therefore stripped himself of his cardinal's robes to become Grand Duke and soon got ready to marry the twenty-four-year-old Christina of Lorraine. An heir was needed. And the city had discovered that the dreams of freedom of a confused, proud yet quarrelsome Republic were worth less than security and stability: the rule of a good prince comforted the Tuscan subjects, and to cite Machiavelli again, "Make us therefore a prince to live and maintain the state, and the means will always be judged honourable and praised by all".[8] We owe the birth of the Opificio delle Pietre Dure to him.

His marriage to Christina was delayed due to the political turmoil in France where Catherine de' Medici was regent. The official wedding was celebrated in 1589 and on that occasion, in addition to the usual decorations, Bernardo Buontalenti arranged the courtyard of Palazzo Pitti as if it were a sort of sea where a performance simulating a naval battle was performed. A new musical genre, known as melodrama, also began life during this period in a hall of the same Florentine palace. On the evening of 6 October 1600, during the celebrations for the marriage between Marie de' Medici and Henry IV of France, whose union Ferdinando himself

had promoted, *Eurydice* – a pastoral fable by Ottavio Rinuccini with music by Jacopo Peri and Giulio Caccini – was performed.

So there were two queens of France and two popes in the Medici family, but by the end of the 16th century Florence was in decline. It had around 70,000 inhabitants, making it a marginal city, not least because trade had declined considerably, although the need for building was still there. In fact, the Belvedere Fort was completed and work began on the Medici Chapels. Furthermore, Ferdinando added to the private Uffizi art gallery, where numerous classical statues that had been in Villa Medici in Rome arrived. His predecessor Francesco had the splendid villa built in Pratolino, to which he also added the Ambrogiana and the villa Artimino.

– I've heard about the home in Pratolino. They say it was splendid…

– The villa at Pratolino was a true marvel, built to amaze visitors and welcome them amidst its water features and woods, while Giambologna's Apennine Colossus still watches over Florence with a grim air from on high. 'Giambologna made the Apennine Colossus but regretted having done it at Pratolino', they said at the time. It was so beautiful that it would have been better admired in a square in Florence. Francesco Buontalenti had the villa built for his Bianca, who loved the peace and quiet, away from the many people who hated her and gossiped about her. The park was dotted with grottoes, fountains, pool and features of great ingenuity. There were all sorts of wonders, with automatons that moved and emerged from the water. This fairy-tale setting came to life during festivals, with fireworks and statues that seemed to become animated in the magic of summer evenings. It left an acute impression on the senses, stimulated by the roar of the water and the artificial rain. It was surely the most splendid, the most extravagant of the Medici villas, designed around water, yet too fragile to survive the passage of time.

– But tell me more about Ferdinando…

– My dear Maria, Ferdinando was a good administrator. He knew how to govern, which was an art he had learnt in Rome when he was a cardinal. He gave a great boost to the city of Livorno, attracting Jews, political refugees and exiles. These new inhabitants gave an international

V. THE 16TH CENTURY. THE GRAND DUCHY

and open feel to the port, which was linked to the city of Pisa via a canal. Ferdinando referred to it as 'my lady'. He and his wife had nine children and for his heir, Cosimo, who would be known as Cosimo II, he organized a fairy-tale wedding with Maria Maddalena of Austria. The most impressive of the various celebrations was the naval battle staged on the Arno. Eight children were born out of that union over the following years.

– And then the fertility of these gentlemen was countered by your generation, which produced no heirs. Oh, forgive me Princess, for what I have dared to say. I must learn to hold my tongue!

– Don't worry Maria, you only told the truth. Unfortunately that's how it was. It seems incredible that with so many branches the tree was left bare. Perhaps there is something wrong with our blood... and as regards my brother, Gian Gastone, I should say the blood is rotten! However, when he died in 1609, Ferdinando, who was certainly loved by his subjects, was the first to take his place in the new Pantheon, the Medici tombs, where I'm taking you now. But first let's go back to our home, Palazzo Pitti. We'll enter a place you know well, but which you've perhaps never really looked at properly. Let's go! I simply have to show you another wonder.

– Oh! To tell you the truth, I've always found the grottoes in the Boboli Gardens very disturbing, Princess.

– This was indeed the aim of Buontalenti, the architect who built them between 1583 and 1593. He drew his inspiration from Ovid's *Metamorphoses*, but not in the sense of the stories but of the progressive metamorphosis from formless matter to the human body and back again.

– Princess, I've noticed that the figures in the stone are blurred and undefined. They seem to appear and then disappear. At the corners I can see Michelangelo's four *Prisoners*, just as you say, imprisoned in marble, struggling to free themselves from the material. All this uncertainty still unsettles me, and I feel like I'm under the surface of the sea.

– The water is certainly striking, but even more so the light coming down from above. Look at the circular opening: there's an aquarium and the movement of the fish creates a unique interplay of reflections. The

walls are covered with limestone reliefs that grow lighter to become frescos, while the figures are composed of stalactites: this is why they seem strange and mutated to you Maria.

– Yes, it's as if the architect wants to turn the world upside down and give us a different vision of it.

– That's right. It's exactly like what was happening at that time: the world had changed and Italy had lost all its importance.

Painted stained glass in the Biblioteca Medicea Laurenziana.

Jacques Callot, *Piazza Santa Maria Novella*, Florence, c. 1622.

VI. The 17th Century

The Century of Iron

nd here comes the 17th century with all its contradictions: the scientific revolution and the Baroque, conflicts and transformations.

– *Life is a dream*, Maria, is what Calderón de la Barca wrote in 1635, when even the great Spanish empire was about to enter the shadows, and with it the Italy that gravitated in its orbit. Naturally this also applied to Florence.

The entire 17th century saw intense scientific activity and a lively music scene. One should not really speak of decadence if painting and sculpture lost their primacy. Economic activities throughout Italy were stagnant and trade declined: Florence and Italy were no longer at the centre of the world. Surprise at this situation turned into actual astonishment following the sudden expansion of the universe due to Galileo's declarations regarding the central position of the Sun and new geographical horizons. Indeed, in 1488 Bartholomew Diaz had rounded what he called the Cape of Storms, which became known as the Cape of Good Hope for this reason. Ten years later, Vasco da Gama circumnavigated Africa, identifying a new route to the Indies. The Florentines also became navigators, starting with Toscanelli who, reworking the findings

made by Strabo and other ancient experts, declared that one could travel to the land of spices via an alternative route, as Christopher Columbus would actually do in 1492, changing the way in which we view the world. The Protestant Reformation, the invention of the printing press that also enabled the distribution of the Bible translated by Luther. In short, the world was no longer what we had imagined and described.

The imitation of nature as a canon of beauty is on the wane. Renaissance harmony is no longer enough to express what is happening and what is felt. There is a need to recount the fascination of the new, to overthrow what is known, to amaze and be amazed at the same time. Just as happened to the sailors who reached the new continent.

In order to depict beauty, one exaggerates, one disquiets. And at the same time, mournful motifs and macabre symbols have made a return in depictions, as if always wanting to emphasize the fleetingness of time and the fatality of death.

– I don't follow you, Princess. I find it all a bit confusing. Astonishment, restlessness, fleetingness… where is the concreteness on which the Renaissance was founded?

– Follow me and you'll understand.

Cosimo II was just nineteen years old when his father, Ferdinando I, died. What's more, he was in poor health that kept him bedridden for long periods of time. He strove for a policy of balance between the great powers that would allow the Grand Duchy of Tuscany to survive the century's storms: wars, famines and plagues. He showed great interest in science and was a friend and protector of Galileo Galilei. The scientist was recalled from Padua to Tuscany in 1610, where he obtained a chair at the University of Pisa, with the title Court Mathematician and Philosopher. For his part, Galileo had dedicated *Sidereus Nuncius* to the Grand Duke, calling the four satellites of Jupiter that he discovered Medicea Sidera ('Medici stars'). In 1616 Cosimo II managed to rescue the scientist from the Roman Inquisition. It was only the first attempt.

His successor, Ferdinando II, also took an interest in science as a child and kept a collection of barometers, thermometers and other scientif-

ic instruments in Palazzo Pitti. He even invented a machine to incubate hen's eggs that he kept in the Boboli lemon house. He promoted the foundation of the Accademia del Cimento, desired by his brother, Prince Leopoldo. The academy supported an experimental approach and boasted the involvement of scientists such as Evangelista Torricelli and Vincenzo Viviani, followers of Galileo. Its motto was 'Provando e riprovando' ('Try and try again') and its emblem consisted of three crucibles. However, Ferdinando was unable to prevent the trial of Galileo Galilei, who was sentenced in Rome to abjure his theories on the central position of the Sun and to acknowledge as truth what is written in the Bible. In fact, the Old Testament states that Joshua stopped the sun, so according to the inquisitors Galileo considered himself superior to the word of God, for that alone counted.

– But couldn't Galileo use the telescope to prove that he was right?
– He did, Maria. They replied that it was true, but they would only accept it if it was written in the Holy Book, otherwise the evidence was worthless. So the poor scientist, who was elderly and sick, was threated with torture and forced to abjure, meaning that he had to deny the theories for which he had fought and struggled and regarding which he was so certain. It was hard for him. Some report that as he was preparing to abjure with his hand raised, he lowered his gaze and uttered the words "And yet it moves" in a low voice, but this is not certain.
– And what happened next?
– After him, fact-based truth prevailed and Dante's universe, the Ptolemaic universe, was overthrown by the Copernican theory. The year 1633 was a turning point: it saw the sentencing of Galileo, but also the birth of science, in the sense of the experimental method.

Walking and talking about the illustrious mathematician, we arrived at the Medici Chapels, and again I saw before my eyes his greatness, like that of Giotto, Dante, Petrarch, Boccaccio, Brunelleschi, Michelangelo and Machiavelli. Geniuses, innovators and masters, along with many other Florentines and Tuscans.

We enter the building.

They open the doors for us with solicitude and lengthy bows. I'm curious to see how Maria will react to all that is about to unfold before her eyes.

– Oh, it's absolutely amazing, Princess. It's different from anything else we've seen so far: the perspective, the geometric rigour. There's nothing simple here. We're immersed in a sphere of coloured glass, multifaceted, dark green, emerald ochre and gold. And it's not clear where the floor ends and the walls begin. There's so much gold shimmering, but at the same time I feel a gloomy, distancing feeling.

– No wonder, Maria. It's still a mausoleum – tombs for a dynasty that would have wanted to reign forever – one of Cosimo I's dreams, developed by his son. A dream on a grand scale that amazed the sovereigns of the time and the Florentines, and that is also considered one of the wonders of the world, a bit like the *Cavalcade of the Magi* we saw at the palace on Via Larga. Wonder, amazement. It really has been a long time.

Here, however, there is a search for the new and the original. Something irregular, something scarcely harmonious, a betrayal of the classical ideal that was based on the imitation of nature, as I have already explained to you. Nevertheless, although I also contributed to the completion of the work, I prefer the tombs in the Old Sacristy, with Donatello's decorations, a work by the great Brunelleschi developed according to a rational geometric concept, over this pomp – and this I will admit only to you. A cube surmounted by a hemispherical dome. Circle and square. Perfection: man feels at the centre of the universe.

– That's right, Princess. Leonardo da Vinci's Vitruvian man.

– Indeed, Maria, I see you remember the lesson well. After all, Cosimo the Elder had himself buried in front of the altar, under the floor in the centre of the church, inside a pillar supporting the presbytery.

– Princess, you'll be laid to rest here too, in the Princes' Chapel, next to your brothers and your father. Perhaps in the future they'll decorate the vault of the dome with lapis lazuli, if you don't do so yourself!

VI. THE 17TH CENTURY. THE CENTURY OF IRON

– I don't think so. Always remember, Maria, what Machiavelli wrote: "men of little prudence will do a thing for an immediate gain without recognizing the poison it bears for the future".[1] And so it is here: one breathes in glory and celebration, but how much poison, alas, lies beneath these tombs! I'm reminded of the portrait I love most among the many that have immortalized me: the picture that Giusto Sustermans painted of us as children with our governess. I've always carried it with me on my travels.

– It's true. I remember it ... always with you on your travels. The innocence of the children and the serenity of their faces is just beautiful.

– You're so right. It's really fascinating!

The red curtain that opens and separates, like a curtain on the stage of our future lives. A theatre, a comedy, or rather a tragedy to be acted. The pose is studied as always, but our eyes reveal a lack of awareness of the future and the restrained joy of childhood. Big round eyes, mine a little bulging. We are as serious as two little grand dukes and Ferdinando is wearing a long, feminine, gold-and-red dress and has long hair. The housekeeper behind us is a reassuring, protective shadow. Our mother Margherita, on the other hand, is an absence

– Princess, are you sad? Take your handkerchief, your eyes are red.

– No Maria, it's just the dust in this place, the dust of passing time ...

– Of course, I understand.

– Let's go back to our story. Where were we?

When he became Grand Duke, Ferdinando II was only eleven years old. Poor Cosimo II had died young and his grandmother Christina of Lorraine and his mother Maria Maddalena of Austria took over the reins of power. Vittoria della Rovere, who was only one year old when the contract was signed, was chosen as the prince's bride.

~ 111 ~

– Just one? Unbelievable …

– Of course. She was the last heir to the Duchy of Urbino, but the regents were unable to oppose the occupation of the small Marche state by Pope Urban VIII on the death of the last duke.

– So she brought the duchy as a dowry?

– No. Unfortunately, the Medici family didn't inherit Urbino, which remained a fiefdom of the Church, but they did receive priceless works of art, furniture and furnishings, splendid paintings such as Titian's *Penitent Magdalene* and Raphael's *Portrait of Julius II*. The political situation was precarious, the predecessor had failed to keep the difficult balance between France and Spain, culminating in the onerous Tuscan intervention in the Wars of Castro to prevent the expansion of papal territories in the southern areas of his state.

– And what was happening in Florence during that period?

– In the meantime, you should know that drawing-room life dominated in Florence, while manufacturing activities declined and the expenses of the court and the bureaucratic apparatus increased. Agriculture was neglected, reclamation works ceased. Despite some interventions by Ferdinando to cut costs by dismantling the military fleet, taxes rose enormously, triggering discontent among the population, who were already struggling. In 1629, the plague also arrived and it was on this occasion that the Grand Duke showed his courage, making public appearances to console and help his subjects. He gained great popularity, but the losses were high, amounting to approximately one tenth of the population. Moreover, during the War of the Monferrato Succession, Florence sent troops to support the Spanish army, and this led to enormous economic sacrifices, but also the indignation of the king of France, a traditional ally and close relative.

Between 1652 and 1656, the Pergola theatre was built on the site of an old workshop that produced woollen cloth, a sign of changing times.

– It's splendid. I've been there before and seen its mirrors and gilded stucco. It was like being in an enchanted fairy-tale palace.

– It was built to a design by Ferdinando Tacca with technical devices to boost the acoustics and sophisticated mechanisms suitable for

scene changes, so much so that it became the model for future Italian and European theatres. Vittoria della Rovere, torn between religion and worldliness, was anxious to convey the image of a Florence that loved luxury and parties, hiding the true face of a city in full decline behind the performance.

The couple was ill-matched and the marriage was not a happy one, despite the birth of two sons eighteen years apart. It was rumoured that Vittoria had discovered her husband's homosexual tendencies for a certain page named Bruto. Apparently, the Grand Duchess Mother had one day presented Ferdinando II with a list of prominent citizens, proclaimed to be sodomites, and demanded exemplary punishment. Her husband, unperturbed, even added his own name in pen. Upon her insisting that they be burned at the stake, Ferdinando merely threw the list into the fire, adding "Here they are punished as you command".

– Really?! I didn't know about these… activities!

– Florence had always been famous for its very strong presence of homosexuals, so much so that in Germany there was talk of Florentine love, and the last Medici were in good company. Among the artists, Leonardo da Vinci, Sandro Botticelli and Benvenuto Cellini were accused of sodomy; while others like Michelangelo managed to avoid the net of justice. And in any case, it was mostly tolerated until the Council of Trent. In fact, on 13 August 1512, thirty young aristocrats, known as 'the Compagnacci', forcibly entered Palazzo Vecchio and demanded an end to the rules that exiled sodomites and stripped them of their property. In September of that year, with the return of the Medici to Florence, the request was granted.

– Dear Maria, let's finish our walk. Today I want to show you the church of Santa Croce. Let's go back to the beginning of our walk, to the past, because that church holds something special and unique for me and for our history.

– Of course Princess. I'd never get tired of following you and learning all these wonderful and important things. I'm so happy that you

have chosen me. Today is such a beautiful day, reminiscent of Botticelli's skies...

The carriage takes us once again from the San Lorenzo district to the Baptistery, resplendent in its green and white colours, and the gold of its doors. The Duomo facade is yet to be completed, as are other Florentine church facades, including San Lorenzo: all signs that economic resources have run out and too much money would be needed to achieve a result that would equal the interior. Finances have been stagnant for over a century now. Those who come after us will need to take care of that. Who knows if these Austrians will feel like it! I think not. At the junction with Canto dei Bischeri we turn right along Via del Proconsolo. I explain to Maria about the Bischeri family, who didn't want to give up their houses for the expansion of the Duomo, convinced that they could speculate on the price, but instead losing everything in a fire that destroyed them. However, she smiles and knows that in Florence this term is synonymous with 'stupid'. Indeed, the Bischeri changed their surname upon their return.

– The Canto dei Cartolai, where we now find ourselves, was once home to the workshops of those who dealt with books, copied them and then sewed the sheets and bound them, with rods and tacks. One always found cultured and refined gentlemen buying precious volumes while discussing art and philosophy. Now there are printers, and the climate that had characterized Humanism can no longer be breathed in here. Remember that we talked about Vespasiano da Bisticci. Instead, a little further on, you can see the house of Matteo Palmieri, an apothecary who had become Gonfaloniere of Justice and ambassador due to his considerable talents during the Humanist era. He was also interested in esotericism and alchemy, and wrote a treatise inspired by the doctrines of the Greek philosopher Origen. It is thought that his body, during a period less open to 'heretical' doctrines, was dug up from the church where he was buried and placed outside the churchyard, due to contempt and anger.

VI. THE 17TH CENTURY. THE CENTURY OF IRON

– Of course the Florentines don't forget. They're capable of bearing resentment even after death, Princess!

– That's very true. You see, that is the Bargello, with the Volognana tower. After being the seat of the government of Florence, until Palazzo Vecchio was built, it became the residence of the head of the Guardia di Piazza, with a tribunal, prison and torture chambers. It was here that Machiavelli was subjected to the twists and turns of the rope; he later proved to be innocent of the plot against the Medici, but in the meantime the poor man had suffered greatly, both in body and spirit.

We carry on a little further before turning onto the Lungarno and encountering the building of San Firenze.

– Here we are, dear Maria, in front of an example of Florentine Baroque. This structure includes the church of San Filippo Neri, once dedicated to San Fiorenzo, built by the Padri Filippini. The facades are recent, from 1715, two years before I returned to Florence, and are inspired by the facade of San Gaetano in Piazza Antinori completed by my father Cosimo III. This is Florentine Baroque, which is less sensational than the Roman version, but still quite stunning, like the backdrop of a theatre. The noble families of the grand ducal court, who were busy building around one of the city's most luxurious areas, wanted to build the most beautiful Baroque church in Florence with San Gaetano. Here is a less grandiose but similar example.

– Of course, baroque, from the Portuguese *barroco*, meaning irregular, grotesque and bizarre.

– Well done! You've done your homework, although here in Florence it is much less sensational. The Renaissance tradition could not be forgotten, nor confused with a bizarre idea.

– Speaking of theatres, even the Uffizi, seen from the Arno, resembles a theatrical and scenic construction, Princess.

– True. Future ideas were already being anticipated with Cosimo I.

Theatre? "Life's but a walking shadow, a poor player, That struts and frets his hour upon the stage, And then is heard no more. It is a tale Told by an idiot, full of sound and fury, Signifying nothing". These lines from Shakespeare's Macbeth come to mind. My brother Gian Gastone understood it well. He was buried with two gold medals, one on his head and one on his chest where the images of his broken statue and a ruined temple are engraved.

He didn't want to be a grand duke, he didn't want to marry Anna Maria of Saxony. Perhaps he would have liked to occupy himself with botany and collections of fakes. The contemptuous way in which he was treated as a young man, even by our father, made him hate the aristocracy as a whole. He was only fond of Violante, our sweet sister-in-law, even though he didn't attend her funeral and the coffin standing under the windows sent him into a frenzy. In Violante he saw his own near end reflected. He was too sensitive, and when he had to play the part of the grand duke, he tried to numb himself with wine and pleasures, to dampen that mixture of boredom, despair and grief that had plagued him since childhood: sloth. It wasn't his fault, and I'm glad that in the end he called me to his bedside and prepared himself to die in a Christian manner.

– But tell me, Princess, what happened when your brother, Gian Gastone, became Grand Duke?

– When he came to power, Gian Gastone, despite having neither aspirations nor a real reform programme, managed to lift the state from our father's torpor and bigotry. He abolished black clothing and imposed French fashion in dress. He appointed competent ministers, such as Filippo Buonarroti and Giulio Rucellai, and when the pope demanded that the latter be dismissed, since he had tried to defend the Medici inheritance from papal aspirations, he refused without discussion. His first measures were precisely to separate the functions of the Church from those of the State: to get rid of the army of friars and ecclesiastics, of a dense network of spies who had to control the conduct of his subjects, and to eliminate the pensions for converts and the large cash payments that Cosimo III lavished on the ecclesiastics. Indeed, to support the luxury of the court and the expenses for proces-

VI. THE 17TH CENTURY. THE CENTURY OF IRON

sions and various functions, Cosimo III had imposed a tax system that hit the very middle classes upon which the Tuscan economy was reliant. Gian Gastone reduced taxes to the great joy of the people, such as those on wheat and 'charity collections'. His father's government had placed a burden on people's finances and damaged culture. It was no coincidence that, in 1727, Gian Gastone paid solemn tribute to the great Galileo and, in the new spirit of tolerance, issued an edict forbidding any persecution of the Jews, who had previously been the object of harsh measures.

Cosimo III: old, proud, obstinate and bigoted. Out of all the painters, he favoured the wax modeller Gaetano Zumbo, who loved to portray the tortures of hell, the effects of the plague and the putrefaction of bodies with meticulous realism, because in his mind the theme of death was dominant. His son Ferdinando, on the other hand, bought Madonnas by Raphael, Andrea del Sarto and Parmigianino, exhibiting them in the cloister of Santissima Annunziata. It was thanks to him that the first art exhibition was held in Florence in 1705. When Ferdinando died, the theatre at Pratolino, one of the most important theatres and a fundamental centre for the diffusion of musical culture at the time, was closed and never reopened.

In 1718, due to changes in international politics, the kingdoms of the Quadruple Alliance (Great Britain, the United Provinces, France and Austria) decided that Gian Gastone should be succeeded on the throne of Tuscany by Prince Don Carlos, son of Philip V of Spain and Elisabeth Farnese, the latter in turn a descendant of the Medici. Cosimo III was enraged but there was nothing to be done. Years later the rumour spread that Gian Gastone was nearing his end, a rumour that drove the Spanish army against Tuscany to occupy it. The news was disproved and everything returned to the way it had been, but when the young Don Carlos arrived in Florence, accompanied by 6000 Spanish soldiers, on 9 March 1732, Gian Gastone welcomed him with all honours, favourably impressed by his jovial and cheerful character, so much so that, officially proclaiming him his heir, he said that with a

stroke of a pen he had managed to have a son and an heir, something he had not been capable of in all his years of marriage.

However, following the War of the Polish Succession, he had to change his will again, naming the former Duke of Lorraine, Francis Stephen, as successor. Some said that he changed the cloth of Spain to that of Flanders. The Second Treaty of Vienna was signed without consulting Gian Gastone, which only obtained autonomy from Vienna for Tuscany, meaning that the Grand Duchy would become an autonomous state with Francis Stephen. In 1748, at the end of the War of the Austrian Succession, the promise was kept.

While Cosimo III had prepared himself daily for the afterlife and died after reigning for fifty-three years, the last of the Medici ruled only fourteen years and was always obsessed with death, reacting with cynicism to the losses of his nearest and dearest, stunned by the army of the *ruspanti*, led by Giuliano Dami, who ruled the court. On 9 July 1737, Gian Gastone, seventh Grand Duke and last of the family, passed away. "He lived 66 years, 1 month, 16 days and 11 hours. He reigned for 13 years, 8 months, 9 days: most just and mightiest prince who will conquer eternity" reads the epigraph.

– Princess, the prophecy of Brandano, the preacher Bartolomeo Carosi da Petroio, came true: "In one thousand seven hundred and sixteen / all healthy, no more Medici [doctors] …"

– Indeed… Look, here we are at Santa Croce, where you've been before, but maybe you haven't noticed a few things I want to show you.

We go inside. It's always exciting for me to be in this place that is so packed with city memories, art and politics. We walk among the large tombstones that hold the remains of ancient families, some now extinct, as I explain to Maria.

– It is so bare and intimate that it really makes you want to pray.
– That's very true. It's bare because Arnolfo di Cambio interpret-

ed the Franciscan spirit. Such large openings served to illuminate those walls on which large frescoes were to be painted for the people to learn the stories of the Bible. This church was built thanks to contributions from important Florentine families. In fact, there are eleven chapels at the back and another five at the ends of the transept. What do you see Maria?

– It's like being in a forest, where instead of trees there are tall, slender columns that soar upwards and culminate in pointed arches. Lines flow through the middle, climbing up to the chiselled, coloured, wooden ceiling. The feeling is one of being lifted skywards. But, at the same time, we are drawn to the back, where the stained glass windows shine and the apse encloses the altar in a precious casket.

– Well done! That's an excellent description of Gothic momentum. And the soft colours – pink, ochre, yellow, green – look like motionless figures and landscapes, all of which are very similar to each other.

You see, these on the right are frescoes by Giotto, the master of all the painters we have seen so far. They tell the story of the life of St Francis. At first the man undresses in front of many spectators, then you see him in his habit receiving something from an angel with open arms, and finally in his bed with his eyes closed. He observes the figures. They are enclosed by the contours of the landscape that almost seems to want to protect the figures.

– And I know that this wooden crucifix is the work of Cimabue, Giotto's teacher. You taught me that Cimabue was captivated by a little boy sitting on the ground drawing a sheep on a slab, he wanted him as a follower and that's how Giotto became great and was the first who was able to look at the world with a natural eye.

– The pupil surpassed the master and after Giotto no one painted in the ancient manner any more.

– So we are to be stunned, as if we were in paradise?

– Yes, but we must then reflect on why this city was the cradle of the Renaissance. How do we explain the presence of two geniuses like Giotto and Dante? And the development of a strong aesthetic

sense? Can it be explained by constant contact with beauty? Or the Florentines' habit of gathering in palace halls and loggias to discuss all sorts of issues? Or the desire to expand cultural horizons, that form of active politics that allowed rich merchants and humble artisans to sit side by side in the Signoria during the communal era? Or perhaps a strong sense of belonging to one's city, despite the hatreds and factions?

– I don't know how to answer you, Princess… but I note that although all these things together have contributed to making Florence great, we are now forced to tread on the graves of those who came before us…

– Yes, and there are many on the ground here, like Ghiberti's, or monumental ones like Michelangelo's. Machiavelli and Galileo also rest in this place. Brunelleschi, on the other hand, is buried in the Duomo, Donatello in San Lorenzo next to Cosimo the Elder, Leonardo in France, although it is not known where exactly, and Dante Alighieri in Ravenna where I think he will remain. Here, you and I, and others too, should reflect on these greats and how to honour their memory, so that nothing is lost and oblivion does not erase everything, while the sands of time run inexorably over our humble lives. I promise that I will do all I can to prevent profligacy, for as long as I am alive.

– Princess, you've done much for this city, with the family covenant you have donated the entire Medici heritage, so that it will not be dispersed and will survive oblivion, here where it was forged. The envied presence of this unique lineage. You close the circle, from Giovanni di Bicci to Anna Maria Luisa. Yours is the magnificent gesture of the last Medici princess. Nothing is to be "taken away from the Capital and State of the Gran Duchy".

– I had no descendants, neither did my two brothers Ferdinando and Gian Gastone. It's a family whose branches have withered, but which is still kept alive by its roots because time is fleeting and as the great Petrarch says:

> Life flies, and never stays an hour,
> and death comes on behind with its dark day,

and present things and past things
embattle me, and future things as well.[2]

I too often think about death. However, with this pact, I've calmed myself. I did what was in my power to prevent the dispersal of our most precious treasures. I've thought of my subjects, even though they have never loved me as much as I would have wished, all of them blaming me for my haughtiness and lack of offspring. But I have arranged a great legacy for them. And this legacy is like a daughter that I entrust in swaddling clothes to the Florentines so that they will raise and guard her and Florence will be reborn from its dark days. I hope they will take care of it.

Tombstone in the cloister of San Lorenzo, Florence.

EPILOGUE

The Electress died on 18 February 1743 during the Carnival celebrations. The theatres were deserted and masks were banned. At last, Maria Luisa de' Medici could also remove her Electress mask to simply be herself. During her final years her main occupations had been charity work and she had also completed the family mausoleum, where she is buried. "She left in a blizzard, and then the sun came out, just as it did for her brother Gian Gastone", people said with amazement and emotion.

"Well, well, then let's do what needs to be done, and quickly", feeling the end to be near. She went to confession and took communion. She declared that she did not want to be embalmed. The city gates were closed to prevent the news from getting out quickly and reaching the Spanish. "I prefer the Lorraines to the Spanish, because they would take the clothes off my back [possessions], and the latter would also take away my skin [freedom of thought]", she seems to have said during that period in Florence.

What happened next, as had been predicted, was the succession of the Lorraines, commemorated by the Triumphal Arch at the San Gallo Gate, built in 1739. Francis Stephen and Maria Theresa of Austria, however, left in a hurry, leaving the Prince of Craon in charge. He took

urgent measures to restore the disastrous finances. With Peter Leopold, who resided in Florence, the Grand Duchy separated definitively from the government in Vienna, but in fact remained a Habsburg satellite. In any case, from a cultural point of view, he benefited from the changes brought about by the policies of his enlightened absolutism, for which his reforming work should be remembered. In fact, Lorraine was responsible for the abolition of the death penalty and torture in Tuscany, but this measure seems to have already been implemented by Gian Gastone who, in his own bizarre and incoherent way, had in any case rejuvenated the Grand Duchy, anticipating a few reforms and freeing himself from the interference of friars and prelates.

AFTERWORD

The bibliography on Florence is endless and varied. I have consulted numerous volumes and documents, trying to remain faithful to the facts as others have reconstructed them before me. As far as the thoughts and considerations of the Electress are concerned, I declare here that I have taken liberties and added a few inventions with regard to Maria, a character who would not otherwise have been examined in depth in history books. Maria is barely mentioned in some texts and is simply described as a loyal follower of the Electress, to whom the latter was apparently very close. Writer Maria Rosa Cutrufelli writes "Telling stories is a delicate art that requires responsibility. Especially when great History moves behind the fictional characters, complete with its unresolved issues, its lies, its dead ends".[1] It goes without saying that responsibility is necessary, but as Manzoni argues in *Lettre à monsieur Chauvet*, "Every secret of the human soul is revealed, everything that generates the great events, everything that characterizes the great destinies, is revealed to imaginations endowed with sufficient sympathetic force. Everything that the human will has that is strong or mysterious, and misfortune that is religious and profound, the poet can guess; or, to put it better, can glimpse, grasp and express".[2] And it should be remembered that, for the final draft, the

~ 125 ~

author of *The Betrothed* came to Florence to listen to the living language in order to "rinse his clothes in the Arno" and to be inspired by the idiom spoken at his time. Manzoni therefore laid claim to the autonomous space of poetry with respect to history, so as to reconstruct feelings and passions ignored by historians. In fact, in Vasari's *Lives*, which are often the primary source for the biographies of so many artists, the author probably invents where he does not know: a wonderful text that also enchants us with the beauty of the language and the richness of the details.

Finally, Harold Acton's book, *The Last Medici*, published in the 1930s, was of great help, even though very few pages are dedicated to the Electress. However, I must admit that the city of Florence with its splendid monuments, portraits, frescoes and sculptures, the city where I have the privilege of living, and whose documents I have studied at length by frequenting archives and libraries, was the thing that inspired me above all others.

NOTES

Chapter I. The Promise

1 Dante, *Purgatorio*, IV. 9: "Vassene 'l tempo e l'uom non se n'avvede".

Chapter II. Origins

1 Today's Piazza della Repubblica.

2 The ancient Via Calimala continues today on Via Roma.

3 Dante, *Inferno*, XV. 67–9 and 73–5: "Vecchia fama nel mondo li chiama orbi; / gent'è avara, invidiosa e superba: / dai lor costumi fa che tu ti forbi / ... / Faccian le bestie fiesolane strame / di lor medesme, e non tocchin la pianta, / s'alcuna surge ancora in lor letame".

4 Giovanni Villani, *Nuova cronica*, [1322–48], critical ed. by Giuseppe Porta, 3 vols., Parma 1990–1, I (1990), pp. 121–3.

5 Approximately 24 metres.

6 Dante, *Inferno*, X. 35–6: "ed el s'ergea col petto e con la fronte / com'avesse l'inferno a gran dispitto".

7 Ibid., v. 85: "lo strazio e 'l grande scempio che fece l'Arbia colorata in rosso".

Chapter III. The 14th Century

1 Dante, *Paradiso*, XVII. 58–60: "... sì come sa di sale / lo pane altrui, e come è duro ·calle / lo scendere e 'l salir per l'altrui scale".

2 Dante, *Purgatorio*, VI. 76–8: "Ahi serva Italia, di dolore ostello, / nave sanza nocchiere in gran tempesta, / non donna di province, ma bordello!".

3 Villani, *Nuova cronica*, ed. 1990–1, III (1991), p. 1351.

4 'Decameron' is a compound word that comes from ancient Greek – *deka* and *hemerón* – and literally means 'of ten days'.

5 Leonardo Bruni, *Le vite di Dante e de Petrarca ... cavate da un Manuscritto antico della Libreria di Francesco Redi e confrontate con altri testi a penna*, [1436], Florence, 1672, p. 90: "[Francesco Petrarca] fu il primo, il quale ebbe tanta grazia d'ingegno, che riconobbe, e, rivocò in luce l'antica leggiadria dello stile perduto, e spento".

Chapter IV. The 15th Century

1 Ancient Tuscan name for Carnival.

2 Lorenzo the Magnificent, *Canzona di Bacco*, ll. 1–8: "Quant'è bella giovinezza / che si fugge tuttavia! / Chi vuol esser lieto, sia: / di doman non c'è certezza. / Quest'è Bacco e Arïanna, / belli, e l'un dell'altro ardenti; / perché 'l tempo fugge e inganna, / sempre insieme stan contenti".

3 Ibid., ll. 53–8: "Ciascun suoni, balli e canti, / arda di dolcezza il core: / non fatica, non dolore! / Ciò che ha esser, convien sia. / Chi vuole esser lieto, sia: / di doman non c'è certezza".

4 Vespasiano da Bisticci, *Vite di uomini illustri del secolo XV*, printed for the first time by Angelo Mai and again by Adolfo Bartoli, Florence, 1859, p. 260: "Voi andate dietro a cose infinite, e io alle finite; e ponete le scale vostre in cielo, e io le pongo rasente la terra, per non volare tanto alto che io caggia".

5 Giorgio Vasari, *Le Vite de' più eccellenti pittori, scultori, et architettori*, ... revised and enlarged, 3 vols., Florence, Giunti, 1568; in id., *Le Vite... nelle redazioni del 1550 e 1568*, edited by Rosanna Bettarini, commentary by Paola Barocchi, 6 vols., Florence, 1966–87, III, p. 156: "E ci fu uno che propose empierla di terra e mescolare quattrini fra essa, acciò che, vòlta,

dessino licenzia che chi voleva di quel terreno potessi andare per esso, e così in un sùbito il popolo lo portassi via senza spesa" ("Nor were there wanting men who said that it would have been a good thing to fill it with earth mingled with small coins, to the end that, when it had been raised, anyone who wanted some of that earth might be given leave to go and fetch it, and thus the people would carry it away in a moment without any expanse"; English translation by Gaston du C. de Vere, 2 vols., ed. New York, 1996, I, p. 535.

6 Over 50 metres.

7 Vasari 1568, ed. 1966–87, III, pp. 168–9.

8 Ibid., III, p. 188.

9 Niccolò Machiavelli, *Il principe ... al magnifico Lorenzo di Piero de Medici. La vita di Castruccio Castracani da Lucca a Zenobi Buon Delmonti et a Luigi Alemanni descritta per il medesimo*, [posthumous edition], Rome, Antonio Blado d'Asola, 1532, p. 24: "e però, bisogna che egli habbia uno animo disposto à volgersi, secondo che i venti, e le variation' de la fortuna gli comandano".

10 Today's Via Cavour.

11 Vasari 1568, ed. 1966–87, IV, p. 30: "Prese Lionardo a fare per Francesco del Giocondo il ritratto di mona Lisa sua moglie; e quattro anni penatovi, lo lasciò imperfetto: la quale opera oggi è appresso il re Francesco di Francia in Fontanableò" ("Leonardo undertook to execute, for Francesco del Giocondo, the portrait of Monna Lisa, his wife; and after toiling over it for four years, he left it unfinished; and the work is now in the collection of King Francis of France, at Fontainbleau"; English translation by Gaston du C. de Vere, 2 vols., ed. New York, 1996, I, p. 635).

12 Petrarch, *Canzoniere*, ed. by Ugo Dotti, introduction by Ugo Foscolo, notes by Giacomo Leopardi, Milan, 2003 (1st ed. Milan, 1979), CCXXIX, ll. 1–2: "Cantai, or piango, et non men di dolcezza / del pianger prendo che del canto presi".

13 Niccolò Machiavelli, *Le Istorie fiorentine*, posthumous edition by Pietro Fanfani and Luigi Passerini, 2 vols., 1873–4, I (1873), p. 422: "nelle cose veneree maravigliosamente involto".

14 Lorenzo the Magnificent, sonnet no. 25,

l. 1: "Tante vaghe bellezze ha in sé raccolto / il gentil viso della donna mia".

Chapter V. The 16th Century

1 Machiavelli, *Il principe*, ed. 1532, p. 33: "iudico poter' esser' vero che la Fortuna sia arbitra de la metà à le attioni nostre. Ma che ancora ella ne lasci governare l'altra metà ò, poco meno à noi. Et assomiglío quella à un' fiume rovinoso, che quando è s'àdira, allaga i pian, rouina gli arbori, e li edifícy" ("I consider it to be true that Fortune is the arbiter of one half of our actions, but that she still leaves the control of the other half, or almost that, to us. I compare her to one of those destructive rivers that, when they become enraged, flood the plains, ruin the trees and buildings"; English translation by Peter Bondanella, ed. New York, 2005, I, p. 84).

2 Niccolò Machiavelli, *Lettere*, preface by Giovanni Papini, 2 vols., Lanciano, 1915, I, pp. 24–7: 26: "m'ingaglioffo per tutto dì giuocando a cricca, a trich-trach ... Venuta la sera, mi ritorno in casa, et entro nel mio scrittoio ... et mi metto panni reali et curiali; et rivestito condecentemente entro nelle antique corti degli antiqui huomini".

3 Dante, *Purgatorio*, VI. 76: "Ahi serva Italia, di dolore ostello".

4 Dante, *Inferno*, III. 8: "Dinanzi a me non fuor cose create se non etterne e io etterno duro".

5 Machiavelli, *Il principe*, ed. 1532, p. 9: "Da qui nacque che tutti li Propheti armati vinsono, et li disarmati rouinorono" ("From this comes the fact that all armed prophets were victorious and the unarmed came to ruin"; English translation by Peter Bondanella, ed. New York, 2005, I, p. 22).

6 Vasari 1568, ed. 1966–87, III, p. 476: «Per che, essendo egli dotato dalla natura d'uno spirito perfetto e d'un gusto mirabile e giudicioso nella pittura, quantunque orafo nella sua fanciullezza fosse, sempre al disegno attendendo venne sì pronto e presto e facile, che molti dicono che mentre che all'orefice dimorava, ritraendo i contadini et ogni altra persona che da bottega passava, li faceva sùbito somigliare, come ne fanno fede ancora nell'opre sue infiniti ritratti che sono di similitudini vivissime» ("Endowed by nature with a perfect spirit and with

NOTES

Giuseppe Zocchi, *Biblioteca Medicea Laurenziana*.

an admirable and judicious taste in painting, although he was a goldsmith in his boyhood, yet, by devoting himself ever to design, he became so quick, so ready, and so facile, that many say that while he was working as a goldsmith he would draw a portrait of all who passed the shop, producing a likeness in a second; and of this we still have proof of an infinite number of portraits in his works, which show a most lifelike resemblance; English translation by Gaston du C. de Vere, 2 vols., ed. New York, 1996, I, p. 516).

7 Petrarch, *Canzoniere*, ed. Dotti 2003, CCLXIX, ll. 12–14: "O nostra vita ch'è sí bella in vista, / com perde agevolmente in un matino / quel che 'n molti anni a gran pena s'acquista!".

8 Machiavelli, *Il principe*, ed. 1532, p. 24: "Facci adunque un' Principe di viver', e mantener' lo Stato, i mezi seranno sempre giudicati honoreuoli, e da ciascun' lodati".

Chapter VI. The 17th Century

1 Machiavelli, *Il principe*, ed. 1532, p. 19: la poca prudentia de gli huomini, comincia una cosa che per saper' à l'hora di buono, non manifesta il veleno che v'è sotto".

2 Petrarch, *Canzoniere*, ed. Dotti 2003, CCLXXII, ll. 1–4: "La vita fugge, et non s'arresta una hora, / et la morte vien dietro a gran giornate, / et le cose presenti et le passate / mi dànno guerra, et le future anchora".

Afterword

1 Maria Rosa Cutrufelli, *I bambini della ginestra*, Milan, 2012, p. 267: "Raccontare storie è un'arte delicata che richiede responsabilità. Soprattutto quando dietro i personaggi d'invenzione si muove la grande Storia, con le sue questioni irrisolte, le sue menzogne, i suoi vicoli ciechi".

2 *Lettere sui Promessi sposi*, edited by Giovanni G. Amoretti, Milan, 1985, p. 17: "Ogni segreto dell'anima umana si svela, tutto ciò che genera i grandi avvenimenti, tutto ciò che caratterizza i grandi destini, si rivela alle immaginazioni dotate d'una sufficiente forza di simpatia. Tutto ciò che la volontà umana ha di forte o di misterioso, e la sventura di religioso e di profondo, il poeta può indovinarlo; o, per meglio dire, scorgerlo, afferrarlo ed esprimerlo".

~ 129 ~

Veduta del Reale Palazzo de Pitti Abitazione de Regnanti Sovrani.

Palazzo Pitti.

TABLE OF CONTENTS

Genealogical tree of the Medici family	4
I. The Promise	7
II. Origins. *Florentia antica*	21
III. The 14th Century. Merchants and bankers	35
IV. The 15th Century. Renaissance	49
V. The 16th Century. The Grand Duchy	83
VI. The 17th Century. The Century of Iron	105
Epilogue	123
Afterword	125
Notes	127

Printed in October 2023.